LEGEND

TIPPECANOE
TO TIPP CITY
OHIO

Pastor Jeff and Jackie,
Welcome to Tipp City!
Everyone has a story to tell!

Susan Furlong

A gift from Ruth Ann White

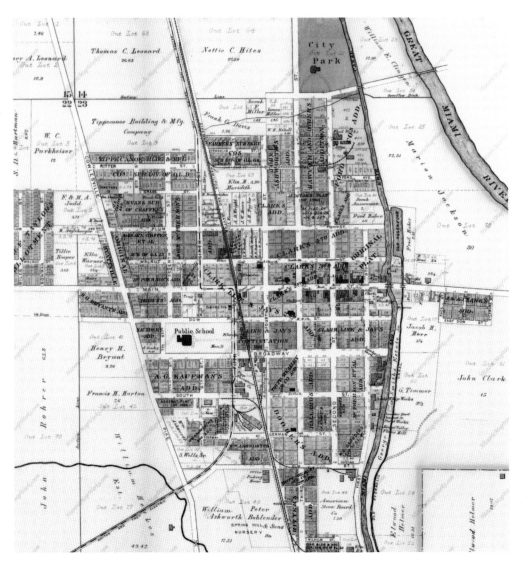

This is an early map of Tippecanoe. Lots were plotted west from the Miami and Erie Canal. Many of the names of the early property owners are mentioned in this book. (Courtesy of Historic Map Works.)

Page 1:
The design for the Tipp City logo, which incorporates the historical significance of the Tipp City Mum Festival, was adopted on April 5, 2010. (Courtesy of Janice Bates, clerk of council.)

LEGENDARY LOCALS
— OF —

TIPPECANOE TO TIPP CITY
OHIO

SUSAN FURLONG

Copyright © 2014 by Susan Furlong
ISBN 978-1-4671-0159-2

Legendary Locals is an imprint of Arcadia Publishing
Charleston, South Carolina

Printed in the United States of America

Library of Congress Control Number: 2014930447

For all general information, please contact Arcadia Publishing:
Telephone 843-853-2070
Fax 843-853-0044
E-mail sales@arcadiapublishing.com
For customer service and orders:
Toll-Free 1-888-313-2665

Visit us on the Internet at www.arcadiapublishing.com

Dedication
This book is dedicated to all the people who were so busy living their lives that they didn't know they were living history.

ON THE FRONT COVER: Clockwise from top left:
Liz and Jerry Miller portraying Hartman and Grace Kinney (Courtesy of the Tippecanoe Historical Society; see page 68), Ron Re (Courtesy of Ron Re; see page 80), Otto and Isabel Frings (Courtesy of the Tippecanoe Historical Society; see page 26), John Clark (Courtesy of the Tippecanoe Historical Society; see page 13), Robert Evans's descendants at his grave (Photograph by author; see page 122), Mary Lou and Jim Wilson (Photograph by author; see page 84), Jackie and Katie Wahl (Photograph by author; see page 91), Ned Sprecher (Courtesy of Patti Sprecher; see page 108), Sam Wharton (Courtesy of Kim Wharton; see page 58).

ON THE BACK COVER: From left to right:
A gathering of people during the late 1800s (Courtesy of the Tippecanoe Historical Society; see page 116), the class of 1961 in the 2011 Mum Festival Parade (Courtesy of Carla Ungerecht, editor of the *Tippecanoe Gazette*; see page 116).

CONTENTS

Acknowledgments 6

Introduction 7

CHAPTER ONE How We Began 9

CHAPTER TWO Building Prosperity 17

CHAPTER THREE Educating for the Future 43

CHAPTER FOUR The Families behind the Street Names 61

CHAPTER FIVE In Service to Others 67

CHAPTER SIX Those We Remember 95

CHAPTER SEVEN The Robert Evans Legacy 115

About the Organization 125

Index 126

ACKNOWLEDGMENTS

My husband, Greg, had the idea for this book. He said, "Why don't you write a book about the characters of Tipp?" What a great idea! I could write about the people who lived the history, so we brainstormed a list of names, and I started my research. A few weeks later, I searched the Arcadia Publishing website to see if they had a category for these "characters," and they did. It was a series called Legendary Locals, and this book was born.

This is my second book about Tippecanoe and Tipp City, and neither one could have been accomplished without the friendship, support, and enthusiasm of the people of Tipp City. I have talked to so many who shared their memories and their photographs. Every person had an unforgettable story to tell, and I wish I could have fit more of them into the book. But I thank everyone for letting me hear the stories of their lives.

I thank Amy Perryman from Arcadia Publishing for her first words of encouragement: "Your [proposal] photographs were all scanned perfectly!" I also thank Lily Watkins, who took over as my editor in the last weeks of the project.

My thanks go to the people who generously shared their own research: Sandra Spangler, Gene Maddux, Joyce Kister, and Betty Eickhoff. My hat especially goes off to Susie Spitler for helping me find the right places to look and the right people to ask.

My love and appreciation go to my family, Greg, Luke, Melissa, and Allison, for understanding my distraction during the writing of this book, and to my friends, who did the same.

I am in love with this town, its history, and its people. My hope is that, someday, someone will look back at the photographs and captions in this book and say, "That's my grandfather," or, "she was my mom's friend," or, "now I understand what happened." I hope that such reactions will, in turn, inspire them to collect their own history.

Every generation is the beginning of the next. Remember them all.

All photographs are courtesy of the Tippecanoe Historical Society unless otherwise noted.

INTRODUCTION

Tippecanoe, now Tipp City, in Miami County, Ohio, had its start with the ingenuity of two young men determined to make their fortunes in the wilderness of the 1830s. Uriah and James Johns, two brothers, had heard about the coming of the Miami and Erie Canal. While many called the waterway "Brown's Folly," after Gov. Ethan Allen Brown, who proposed it, the Johns brothers knew otherwise. They searched out the surveyor in the woods and tried to get him to reveal information on the proposed route, but the man was evasive. They tried bribing him, but again, no luck. As a last resort, they plied him with copious amounts of whiskey. The man spilled his guts!

Armed with the canal route, the Johns brothers began buying land, including a prime location on Lock No. 15 of the canal. They sold that parcel back to the state for a profit and then built a gristmill there, using the canal water to power it. Thus, their fortunes were made in what would soon be Tippecanoe.

The Johns brothers were not the only ones who saw opportunity in the unsettled land of southwest Ohio. Robert Evans purchased 140 acres, then sold the land to his brother-in-law, John Clark, who established the town. Men such as Thomas Jay, Jacob Rohrer, and Sidney Chaffee knew that hard work and forward thinking would bring them fortune and, more importantly, would allow them to build prosperity for their children and their children's children.

Lots were purchased, and houses were built. As the town grew, so did the need for schools, doctors, and shopkeepers. A civic government was formed, and men such as Levi Booher, James Scheip, and Charles Trupp stepped up to serve their neighbors by providing law and order, a fire department, and maintenance of the city streets. They organized the infrastructure needed to improve the standard of living for everyone in Tippecanoe.

Transportation has always been key to the development of Tippecanoe. The town initially grew up along the Miami and Erie Canal, but soon the railroad gained prominence. Still later, the electric traction car arrived, followed by the automobile, and then bus transportation, each in turn becoming the fastest and easiest way to transport goods and to get around. As each of these modes of transportation became obsolete, people had to improvise and improve the way they did business. Because they were successful, more people arrived in Tipp City with fresh ideas and new plans. Jake Detrick, Gerhart Timmer, Peter Bohlender, John Garver, and many others thrived, and Tipp continued to grow and prosper.

The schools of Tippecanoe have also been on the forefront of innovation. James Bartmess eliminated the traditional one-room schoolhouse in favor of placing children in classrooms according to age and ability. In the 1960s, Tipp City introduced a nongraded system whereby a primary student could work through curriculum and grade levels at his or her own pace. People such as L.T. Ball, Nevin Coppock, Mary Butler, and Mary Kyle Michael are well known for providing a first-rate education to all of Tipp City's children.

Friday nights at the football field have always been well attended. For years, all the downtown stores closed early on Friday nights. Signs on the doors read, "Closed. Football game tonight." Appreciated for their contributions to athletics are people like Carl "Jointer" Clawson, Allen "Alkie" Richards, and Dr. Albert Howell, along with many others. The community also supports the arts, through the work of citizens like Stewart King, Ann Keppel, and Gail Ahmed.

Tipp City has an active chamber of commerce and a community services board that oversees community-wide programs. The Downtown Business Partnership is a group of business owners, government officials, and residents interested in promoting and preserving the downtown area. The Tipp City Players, a community theater, has been active for many years, as has the local cable television station, KIT-TV, which films and telecasts Tipp City events. Community events include weekly band concerts in the summer, a Winter Tour of Historic Homes, and numerous downtown gatherings, to

name a few. One of the most widely known events is the annual Mum Festival in September, which has welcomed hundreds of people into town since 1959.

Timely mail delivery has been a source of concern for Tippecanoe since its beginning because of mix-ups with a town in eastern Ohio of the same name. In 1938, town leaders decided that the confusion had to end, so they petitioned to have Tippecanoe's name officially changed to Tipp City. This name change was not without controversy, but the "heart and soul" of the community remained unaffected.

Today, the face of Tipp City looks very different from the Tippecanoe of 1840, but the people who live here continue to enjoy a common history and a common love for their town and its residents. Jim Bayliff, Jim Kyle, Matthew and Claire Timmer, Ron Re, Dave and Sue Cook, Peg Hadden, Jackie Wahl, and many others continue to dedicate their time to bringing the community together.

This book includes only a few of the hundreds of men and women who have made Tippecanoe, and now Tipp City, a great place to live. It is a cliché to say that the more things change, the more they stay the same, but this adage applies to this town in Miami County, Ohio. Some things, like the landscape, the stores, and modern conveniences have changed dramatically over the last 175 years. But Tippecanoe's founder, John Clark, would still recognize the one thing that has stayed the same. The citizens of Tipp City care about their town and their neighbors. A town is only as strong as the people who live there, only as strong as the people who are living its history.

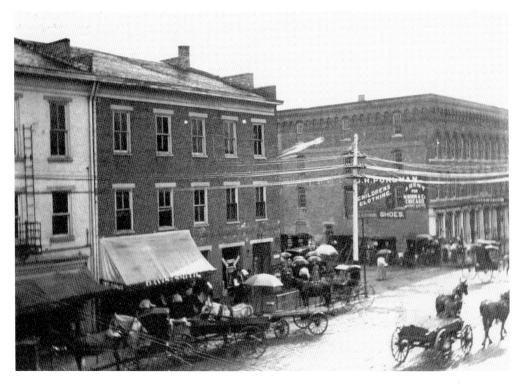

Main Street in Tippecanoe is seen here on a rainy but busy Market Day around 1900.

CHAPTER ONE

How We Began

Hyattsville, a small town that originally surrounded the present-day intersection of Main and Hyatt Streets, was founded by Henry Hyatt. It was one of the first signs of civilization in this part of the southwest Ohio wilderness. But when the Miami and Erie Canal came through about two miles to the east, Hyattsville was eclipsed and eventually absorbed by Tippecanoe.

Robert Evans was the original owner of the 140 acres that became Tippecanoe, but the introduction of the canal and the bawdy life that came with it made him eager to move to a quieter location. Fortunately, John Clark, Evans's brother-in-law, had the foresight to see the potential in owning the property beside the canal, so he exchanged property with Evans, along with $6,750, and he began to plot out lots for a new town.

The availability of faster and cheaper transportation on the canal brought merchants, travelers, and settlers to the area. Travelers needed lodging, food, and drink, so the first businesses were hotels and taverns. The first tavern was owned by Henry Krise, who also operated a dry-goods store and a tailor shop. Thomas Jay bought the first lot in Tippecanoe, building a store and tavern on it. The City Hotel, on the corner of Second and Main Streets, was a bustling business for John Nunlist, who ran it for over 40 years.

Others saw different opportunities in this growing area. Jacob Rohrer was an early settler, and he would eventually become the largest landowner in Miami County. Kiel Hoagland was a boy of only 10 years when he started bringing the mail to Hyattsville on horseback. He would later become a millionaire as one of the owners of Royal Baking Powder, which had its start in Ohio but moved to New York State to find better soil for growing tartar-producing grapes.

Entrepreneurs came to build mills and operate stores to prepare and sell the nearby farmers' crops. Gristmills and granaries dotted the area. The Roller Mill, beside the lock, made the nationally known SnoBall Flour. Because of the ready availability of grain, the whiskey trade developed into big business for men like George Smith, Sidney Chaffee, and Jacob Detrick. Tippecanoe also became known for manufacturing buggy whips at its several large whip factories.

All of this economic growth attracted still more settlers, shopkeepers, entrepreneurs, and their families, and Tippecanoe was now more than a stop on the canal.

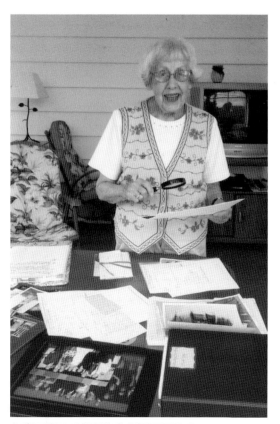

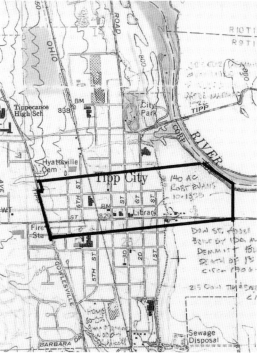

Original Landowner
Robert Evans's direct descendant, Betty Eickhoff, is shown in the above photograph looking over the many photographs and records that she has collected about Evans and his progeny in the Tipp City area. Robert Evans came to Ohio with his family when he was 15, settling on land straddling the Miami and Montgomery county line. As an adult, Evans bought 140 acres in southern Miami County (below), and he began clearing the thick brush for farming. But when the Miami and Erie Canal came through the eastern part of his property, he wanted to protect his 16 children from the rough canal life. He traded farms with his brother-in-law, John Clark, and moved to land between present-day Peters and Evanston Roads. His original house is still standing. In 11 years, he had parlayed a $700 investment into over $7,000. (Above, photograph by author; below, courtesy of Betty Eickhoff.)

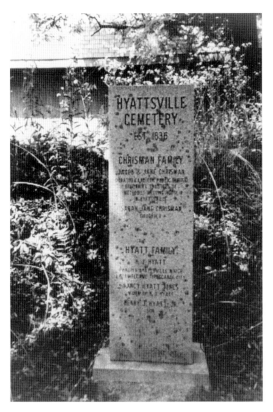

He Built the First Town
In 1833, Henry Hyatt plotted a town on land purchased from Robert Evans. He named it Hyattsville. The town never grew beyond its 27 lots surrounding present-day Hyatt and Main Streets, and it was eventually absorbed by Tippecanoe. Hyattsville, however, continued to maintain the only post office, much to the envy of nearby Tippecanoe, as well as two stores, a tavern, a blacksmith shop, and a church. Shown here is the Hyatt family grave marker. (Photograph by author.)

From Mail to Millionaire
At the age of 10, Kiel Hoagland delivered mail weekly on horseback from West Charleston to Hyattsville. Later as the owner of Royal Baking Powder, he became a millionaire. His biography states, "If he had been told . . . that the day was coming when he could sit in a cushioned carriage of his own with his driver in the box, he would not have believed the prediction."

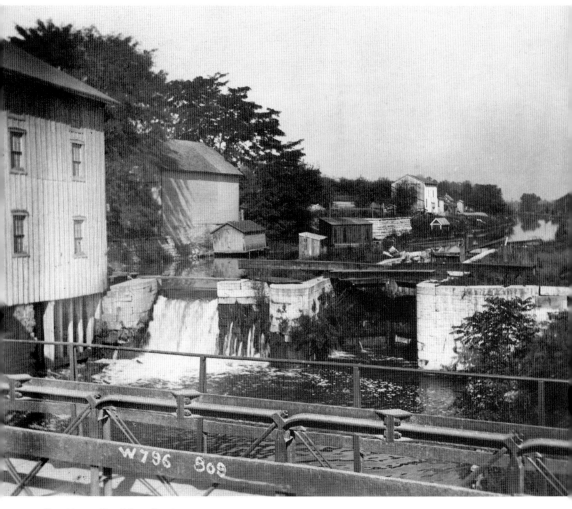

Brothers Seeking Fortune
Tippecanoe got its start with two rascals, brothers Uriah and James Johns. They coerced the secret location of the future Miami and Erie Canal out of the surveyor and promptly bought land along the route. The Johns brothers sold the parcel of land beside the future lock back to the state of Ohio for a profit and built a mill (shown here). Their success was quickly noticed by John Clark, who also understood the importance of the nearby canal. The first industries in Tippecanoe were grain and flax mills, which depended on the canal for the water to power their machinery and to transport their product. While the Johns brothers had a vision for themselves, Clark's vision was much larger. He wanted to bring civilization to this part of Ohio. He wanted to start a town.

CHAPTER ONE: HOW WE BEGAN

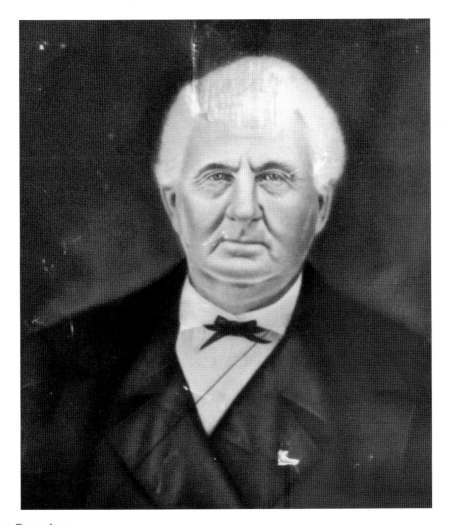

Town Founder

John Clark came to Ohio as a child from Maryland in 1804 with his widowed mother and his stepfather, Michael Fair, as well as several other families. Nearly 30 years later, Clark realized the advantage of building a town along the Miami and Erie Canal at Lock No. 15. He knew that his brother-in-law, Robert Evans, had no interest in founding a town, so Clark quickly bought property about three miles to the west and traded it for Evans's land along the canal. Clark plotted out 17 lots on his newly acquired property and named the community after a man he admired, William Henry Harrison. As the winner of a famous Indian battle in Tippecanoe, Indiana, Harrison had used that battle's name in his 1840 presidential campaign: "Tippecanoe and Tyler Too!" So, Clark's town was called Tippecanoe. The lots sold quickly; soon, more land had to be plotted to accommodate the new arrivals. Tippecanoe was incorporated and granted a charter in the spring of 1851, and Levi Booher was elected its first mayor. Clark decreed that no log cabins would be built in Tippecanoe. He wanted his town to outshine the shabby log cabins in nearby Hyattsville. Clark built his own house just one block west of the canal. The two-story brick home was modeled after the governor's mansion in Maryland. It had large windows for letting in a breeze during the summer months and included a dumbwaiter to carry food from the kitchen in the basement to the upstairs dining room. Clark was able to enjoy his stately home for only seven years before he died at the age of 57. But his legacy remains. His family continued to own the house until it was sold to the Fraternal Order of Eagles in 1937.

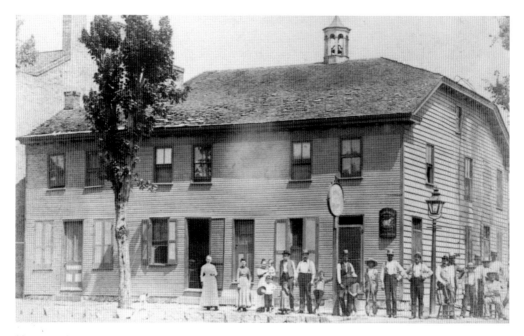

He Bought the First Lot
Thomas Jay bought the first of the original 17 lots that John Clark put up for sale. It was on the corner of Main and Second Streets, where Jay built a general store in the fall of 1839. The building was then sold several times until Joseph Miller operated it as the Exchange House in 1854 (shown here). It later became the Henn House, operated by John Henn.

First Mayor
Another new property owner was Levi Booher. He bought two lots on the corner of First Street and Broadway for $150. The Boohers lived in the smaller house next door while the main house, which now belongs to the Cairns family, was being built. Tippecanoe was incorporated on Monday, May 5, 1851, and Booher was elected its first mayor at age 27. He died just three years later at age 30.

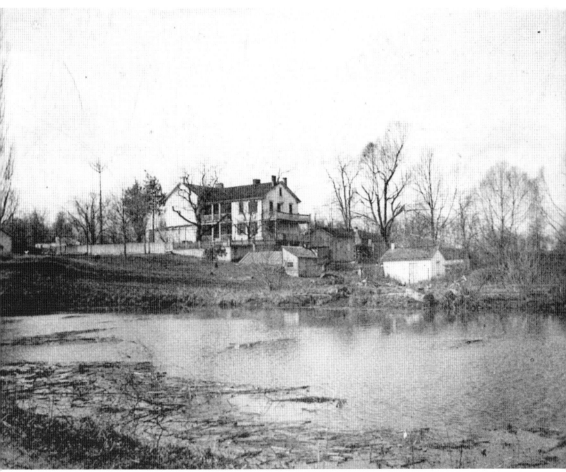

Self-Made Man

Jacob Rohrer, born in 1815 and left fatherless at age 10, had limited opportunities for education. But with hard work and determination, he became one of the largest landowners in Miami County. The early photograph above shows his farmhouse, now on Tippecanoe Drive and surrounded by the houses of Hathaway Village. Several streets were named after his family: Rohrer Drive, Shirley Drive, Judith Drive, Michael Place, and Donview Circle. Rohrer, seated in the front in the below photograph, served on the Tippecanoe Board of Education for many years. He also held manufacturing leadership positions with several wheel works and carriage works, was an officer of the First National Bank and of the Tippecanoe National Bank, and served as trustee for the Knoop's Children's Home. As county commissioner, he helped improve the roads throughout the county, which contributed to the expansion of the area's economy.

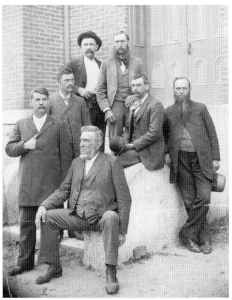

Favorite Family

The Favorite family first came to Ohio when Abraham Favorite traveled from Maryland just before the War of 1812. He had a total of 11 children by two wives, and these children married and had numerous children of their own, thus creating a large line of descendants. Among these descendants was Daniel Favorite, a self-made man who, at his death, left 344 acres to be divided among his children. One of his sons, George, bought his first farm of 80 acres and then increased his landholdings in Miami County to 505 acres. As owner of the George Favorite stock farm, he was considered one of the most "substantial men and progressive farmers and stock raisers in this section of Ohio." Another member of the Favorite family was Jonathan Favorite, an early pioneer in southwest Ohio. He married Mary Hyatt, the daughter of Henry Hyatt, founder of Hyattsville. Their handwritten marriage license is shown above. In 1849, Jonathan left for California to look for gold, and on his way back home, he purchased land in Iowa. After moving his family there, both he and Mary died of typhoid fever, and the children were brought back to Ohio. One of those children, Uriah Favorite, was "farmed out" to a family who mistreated him. Uriah ran away and lived with another family until he reached adulthood and started his business career as a store clerk in Tippecanoe. He enlisted in the Union army during the Civil War and was a member of the Secret Service. After the war, Uriah worked at the glucose factory as a chemist and then as its superintendent. When the factory closed, he purchased and operated the same mill his father had once owned. One of Uriah's children, Harry, is seen in the below photograph at the far right. He married Mary Hartman (second from right), daughter of Dr. Samuel Hartman. Harry Favorite became a real-estate and insurance agent in Tippecanoe. After he died in 1940, Mary continued the insurance business in partnership with her nephew, Hartman Kinney, husband of historian Grace Kinney. The business was eventually sold to Jack and Stan Evans.

CHAPTER TWO

Building Prosperity

A town cannot survive without a prosperous business community that is attuned to changing economic trends, and Tippecanoe was no exception. Tippecanoe was home to several buggy whip factories until the automobile eliminated the need for whips. James Scheip adapted broken buggy whips into carnival whips, and a new industry was begun. During World War II, International Flare produced flare guns for the US military in a factory that previously had made fireworks. After the war, when the military flare industry ended, other factories came to Tipp City to fill different manufacturing needs.

Ladies' hats used to be very much in demand, and Tippecanoe had three stores selling them. Today, vintage clothing, candle, and soap shops are more marketable. The general stores that carried just about everything anyone could want have been replaced by specialty shops, such as Cairns Toys, M&J Gift Boutique, Hapinstance, Urban Ava, and Sugden Furniture.

The nationally known Spring Hill Nursery, whose chrysanthemums are the inspiration for the annual Mum Festival, has changed with the times from a large working nursery to a mainly mail-order business.

Tippecanoe used to be home to a number of small diners on Main Street, but when the I-75 north/south highway came through, fast-food restaurants were established. As a result, the downtown area has adapted. It is now home to Harrison's restaurant, the Coldwater Café, and several sandwich shops and coffeehouses. The City Hotel no longer provides bed and board for travelers, but it does house a variety of small enterprises and shops in its upstairs rooms and a pottery shop on the main floor.

Furniture builders were prominent in Tippecanoe. Lee and Coppock Furniture & Funeral and the Garver Furniture Company were among several such businesses. Today, stores like Benkins Antiques and Midwest Memories sell what the people of yesteryear viewed as contemporary pieces.

Tipp City's downtown district has seen revitalization in recent years. It now is a well-known place to come for a day of shopping in eclectic stores and dining at cozy eateries. The summer of 2013 saw a modernization of the downtown streets with the replacement of sewers, curbs, trees, and the construction of wide sidewalks for leisurely strolling.

An often-used slogan from the past is still true today: "It's worth a trip to Tipp!"

He Strongly Wrought

Sidney Larkin Chaffee came to Ohio on foot from New York in 1840 with 75¢ in his pocket, but with hard work and a clever business sense, he parlayed it into a fortune. His first job in Tippecanoe was running a general store at First and Main Streets. He then opened a distillery at the end of East Dow Street. The whiskey trade became such a booming enterprise that a railroad siding was laid on Dow Street to accommodate the shipping from the eight distilleries and malt houses along First Street. The US government first taxed whiskey in the 1790s as a way to pay down its Revolutionary War debt, and when whiskey manufacturers rebelled against the tax, they were quickly suppressed. In the 1870s, tax scandal erupted again when it was discovered that numerous whiskey distillers had defrauded the government out of its due tax money. This scandal spilled over to Tippecanoe when it was found that the distillery Clark, Dye & Company, owned by Sidney Chaffee, owed $9,312.11 in back taxes. Unable to pay, the company was sold at auction on January 10, 1872. Because the company never carried his name, Chaffee was not held liable, and his fortune stayed intact. As a demonstration of his civic pride, Chaffee donated the money to build the Chaffee Opera House at Second and Main Streets, which in 1857 was the largest facility of its kind in southwest Ohio. It was lavishly decorated in the Victorian style, and although now deserted (below), it provided Tippecanoe with numerous cultural offerings for many years. Sidney Chaffee is also remembered for his courageous character. In the days before antibiotics, cholera was greatly feared. During a widespread cholera epidemic in 1849, Chaffee and Mordecai Clark, son of John Clark, founder of Tippecanoe, risked their lives to care for the sick and bury the dead when few people would have ventured anywhere near the victims. In Chaffee's honor, his descendants donated the Seth Thomas Clock atop the Monroe Township Building. It chimes at noon every day to remind Tippecanoe that Chaffee was "a genial gentleman with a big side to him, a good husband and a kind, indulgent father. He wrought strongly and left evidences of having been here that will always live." (Below, courtesy of Terry Glass; inset, photograph by author.)

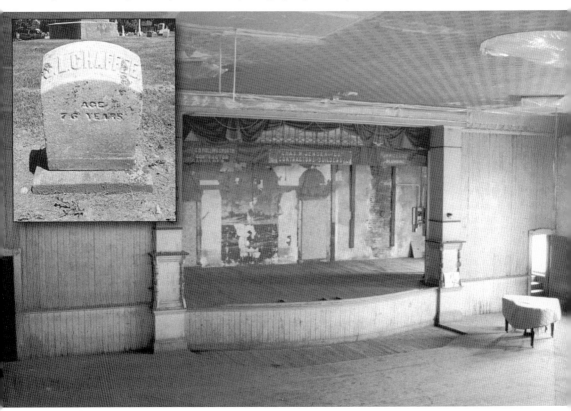

CHAPTER TWO: BUILDING PROSPERITY

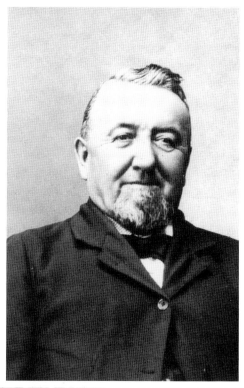

Hotel Proprietor
John Nunlist (left) was born in Switzerland in 1844 and immigrated to the United States at 16. He was bound out to a blacksmith, but in 1862, he ran away to enlist in the Union army. After working as a butcher, Nunlist and his wife, Julia Messmer, ran the Henn Hotel on the northwest corner of First and Main Streets before purchasing the Carle Hotel on the northeast corner of Second and Main Streets. They changed its name to the City Hotel (below) and ran it for 40 years. Nunlist also purchased and sold numerous properties in and around Tippecanoe with his son. He was active in city government and was one of the best-known hotel proprietors in western Ohio. It was said of John Nunlist, "He may truly be called a self-made man for his steady advancement, untiring diligence, guided by sound judgment."

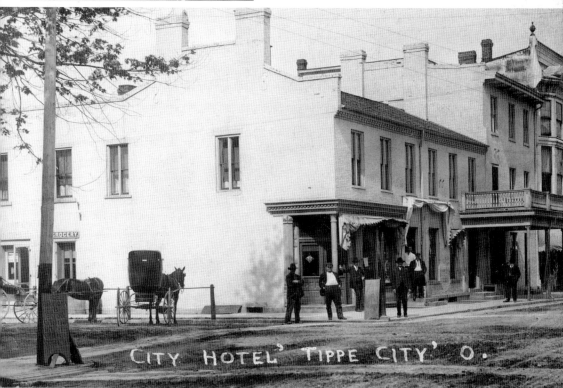

He Did Not Have a Horse

Survival on the streets of Baltimore as a 12-year-old honed James Augustus Scheip's sales and marketing skills. One big seller in his ever-changing inventory was Pink Ladies, small bananas soaked in food coloring and sold for their "medicinal" value. As an adult, Scheip moved to Springfield, Ohio, and worked for a company out of Cincinnati that sold equipment to the Davis Buggy Whip Factory in Tippecanoe. After several trips to install that equipment, he decided to stay and make his fortune. Scheip worked for Davis Whip, but at the same time, he ran several small enterprises out of his horse barn at 228 West Broadway because he said, "I didn't have a horse." One business was upholstering chairs for the parlor cars on the Dayton & Troy Traction Line. Another business developed after the invention of the automobile that put Davis Whip and Tipp Whip out of business. Scheip had been left with a pile of broken buggy whips, so, ever the entrepreneur, he cut them down to make smaller novelty whips for sale at carnivals and fairs. People around town could make extra money by putting whips together at home. A good worker could, after buying unfinished whips by the gross from Scheip's small truck, roll out four dual-colored whips a day and sell them back to Scheip. When his barn was overflowing with whips, Scheip put an advertisement in *Billboard* magazine, and two buyers responded. Scheip said, "When they left all I had left was money." The whips continued to be big sellers at fairs and at the Ringling Brothers Circus until they were outlawed, presumably because children were hurting each other with them. Later, Scheip built his factory, Tipp Novelty, at 222 North Sixth Street to make whips, batons, and canes, and it became one of the Midwest's largest suppliers of novelties, gifts, and concession items. He started two other businesses with his son, Russell: the Safety Corner Company in 1933, which manufactured kitchen glassware; and Tipp Fireworks, which later became International Flare, a leading manufacturer of flares during World War II. Later, Tipp Novelty imprinted logos on vanity mugs and made milk glass shakers and fancy-cut glass items. Scheip was active in the community and served as Tippecanoe's mayor from 1916 to 1923. (Courtesy of Bruce Brownlee.)

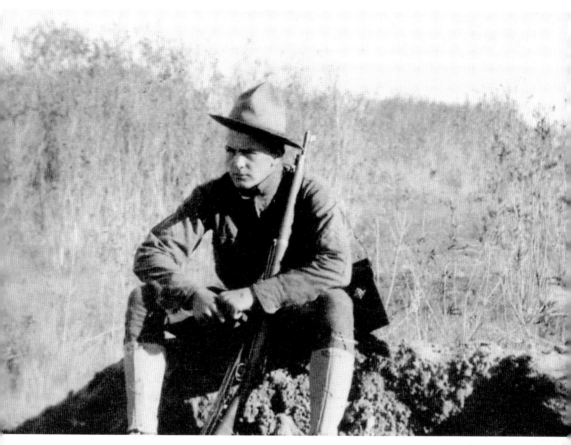

He Fought under Pershing
James Russell Scheip, son of James Augustus Scheip, served under Gen. John "Black Jack" Pershing during the expedition to capture Pancho Villa in 1916. Scheip is seen here resting during that mission. When his father was mayor of Tippecanoe, he served as constable. During a blizzard and Spanish flu epidemic in 1918, people ran out of coal to heat their homes. Henry Ford was shipping 100 train cars of coal to his factories in Detroit, and Scheip stopped the train and arrested the engineer, fireman, and conductor for speeding. While they were in jail, Scheip and Ben Moser uncoupled a car, dumped the coal, and returned the empty car to the train. The train men were fined $5 and sent on their way while paperboys went door-to-door, telling residents where to pick up a free bushel of coal. (Courtesy of Bruce Brownlee.)

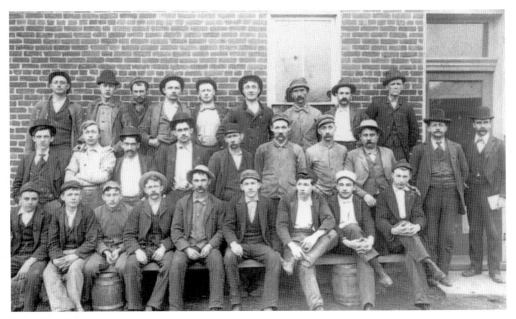

Furniture Builder
Abraham R. Garver was born near New Carlisle. After attending Wittenberg College, he worked for the US Wind Engine and Pump Company as a traveling salesman. In 1889, he organized the Tippecanoe Furniture Company, which operated until 1920. In 1910, he started Garver Lumber. Considered a progressive and public-spirited man, Garver was elected to the Ohio State Senate in 1914. He is pictured on the far right, holding a card.

Flying Daredevil
The oldest son of Abraham and Ida Garver was Karl, the owner and pilot of Garver's Flying Circus in Kansas. The circus was advertised as "a wonderful exhibition of aerial stunts presented by these fearless birdmen, featuring Ruth Garver in a thrilling leap from plane." In 1924, Garver's wife, Ruth, fell to her death. Karl flew for another year before selling the planes. He died of alcohol poisoning in 1926. (Courtesy of Kansas State Historical Society.)

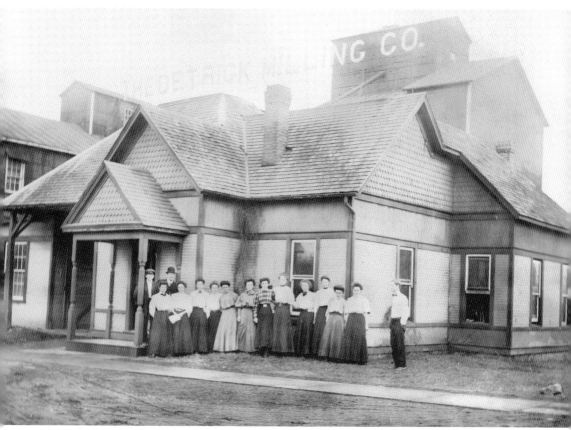

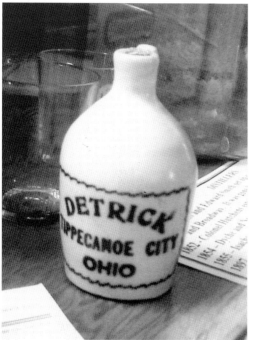

Marketing Genius
The Detrick Distillery (above) in Tippecanoe was owned by Jacob Frank Detrick. He started in the grain business in 1885, but soon branched into the distillery trade. A marketing genius, he used clever mottos on his products. A set of 12 souvenir "Motto Jugs" made of heavy stoneware was popular. Mottos included, "Here's to our wives and sweethearts! May they never meet!" and "Fine old whiskey for medicinal use!" During World War I, Detrick sold alcohol to make smokeless powder for Howitzer guns, but during Prohibition, he returned to the grain business. He also owned several properties, including present-day Spring Meade and the Mauk Cabinets building. Detrick had a fascination with expensive cars and the movie industry. He tried to strike a movie deal with Hollywood. Several starlets visited Tippecanoe, but no deal ever materialized.

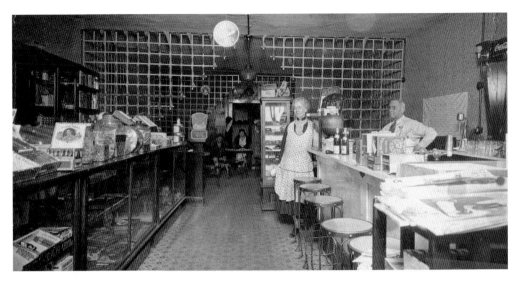

Longtime Business Owner
John "Blackie" and Nellie Smith, pictured above, ran the Blue Bird Tearoom on the southwest corner of First and Main Streets for 60 years. At one time, it was the oldest business in town. One side of the narrow shop was the confectionary counter, selling ice cream and other treats. On the opposite side were cigars and miscellaneous items. Tippecanoe native Gordon Honeyman visited Paris, France, in the 1960s and met a man who had been a cigar salesman in the United States. The man asked if Honeyman knew a town called Tippecanoe and a customer of his, Blackie Smith. Honeyman told the man that Smith had died. The man wrote a letter to Nellie, bringing back her fond memories of "a crazy Frenchman" who spent many evenings at their house smoking cigars and eating her fried chicken. Blackie Smith is pictured below standing outside of his shop.

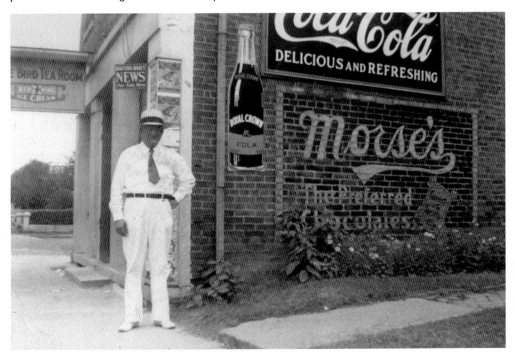

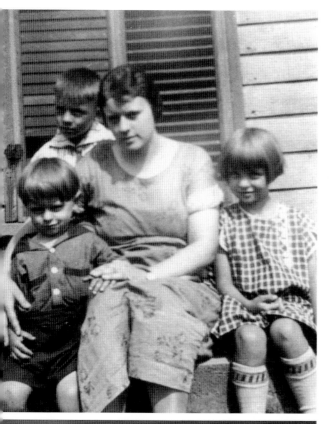

Longtime Beauty Shop Owner
Ruth Sprecher came to Tippecanoe in 1923 with her three young children. From left to right around their mother are Neil, Ned, and Dorothy. Ruth opened her first beauty shop above Sam and Ethel's Restaurant. Later, she moved into the former Chaffee house, where Monroe Federal stands today. Sprecher ran her shop for nearly 40 years in the two front rooms. She was a charter member of the American Legion Auxiliary and the Soroptomist Club. (Courtesy of Patti Sprecher.)

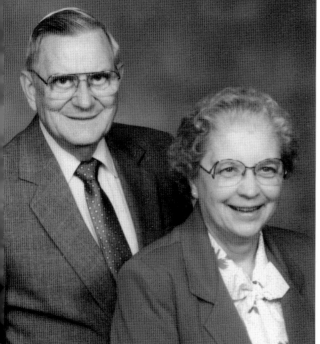

First Citizen of the Year
Shown here are Dorothy Sprecher and her husband, Wilmer Leiss. In 1947, Ned Sprecher, Dorothy's brother, studied the new technique of dry cleaning, and the men ran Leiss Laundry and Dry Cleaning until 1975. Leiss loved to watch firefighters, and whenever he heard a siren, he left immediately for the fire. Leiss was active throughout the community and was named the first Citizen of the Year in 1961. (Courtesy of Patti Sprecher.)

From Furniture to Funerals
Otto Frings was raised in Tippecanoe, and he graduated from high school in 1932. He attended one year at Ohio State University before working for Coppock, Lee, and Rousseau Furniture. Most furniture-makers were also undertakers, because they built coffins. They also provided ambulance service because they had vehicles large enough to carry patients. In 1940, Frings went to embalming school and took over the funeral part of the business. In 1944, he married Isabel Steel, a teacher in the Tipp City Schools, and together, the Frings were active in the community. A World War II veteran, Otto Frings was a member of the Rotary, chamber of commerce, Mum Festival committee, and many other community groups, along with being an avid golfer. In 1976, he was named Citizen of the Year. When Frings died in 2000, he donated his estate to the schools for scholarships.

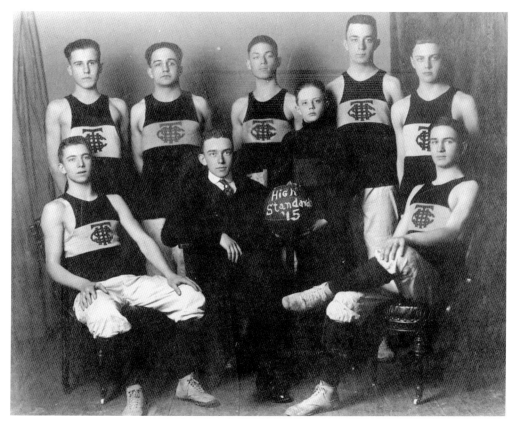

He Owned the Hangout
Carl "Jointer" Clawson was a star athlete in high school in basketball and baseball. In the above photograph, Clawson (second row, fourth from left) poses with the 1915 Tippecanoe basketball team. In that era, he was considered exceptionally tall. He dropped out his sophomore year, but continued playing basketball on a semiprofessional team, the Tippecanoe High Standards. Clawson took over the candy and soda shop operated by his father-in-law Charles Linn when Linn retired. The shop (below) was on Fifth and Dow Streets. For 23 years, Jointer's was a favorite hangout for all ages. It was also the ticket office for the traction line and later the buses. Clawson was a devoted Tippecanoe sports fan, and in 1971, the student senate suggested naming the new baseball field Clawson Field. Clawson said, "I don't know what I've done to earn this other than appreciate what everyone has done for me."

The Family Begins

The Timmer family has been in Tippecanoe ever since Gerhart Timmer arrived from Germany in 1853. He came to Tippecanoe via the Miami and Erie Canal and started Timmer's Cooper Shop. His yard on South Third Street had good clay, so Timmer also made soft red bricks for houses. Shown left is Gerhart's house on Second Street, built with Timmer bricks. He walked to California and accumulated a fortune during the Gold Rush. Upon his return, he built the Timmer Building, now the Coldwater Café, and established the Miami Citizens Bank. He was a stockholder in the American Strawboard paper mill, which later housed Tip Top Canning. Still later, he sold his holdings, purchased 350 acres near Fulton Farms, and went back to his first love, farming. Pictured below are Gerhart (seated, center), his wife, Wilhelmina (seated, second from left), and nine of their ten children. (Left, photograph by author; below, courtesy of Claire Timmer.)

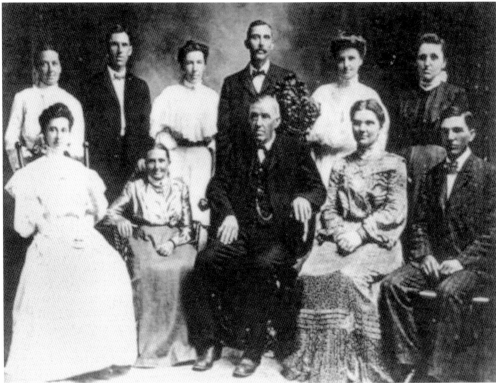

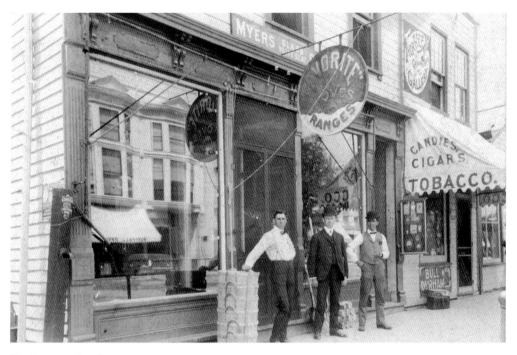

He Began the Cannery

The youngest child of Gerhart and Wilhelmina Timmer was Albert Wilhelm, sometimes called A.W., but known as Pete. He and his brother Ed managed the Timmer Hardware Store until 1907. In the above photograph, Ed (left) and Pete (right) pose with an unidentified salesman. Pete was later shipping clerk for Davis Whip and then freight agent for the Dayton and Electric Railway. He was county auditor in 1911 and, eight years later, the assistant cashier at the Miami Citizens Bank. In 1924, Pete, Ed, and Newman Buckles bought Tip Top Canning on First Street at a sheriff's sale. They reestablished the business in conjunction with Timmer Farms held jointly by Gerhart's heirs. Timmer married Lota Hartley in 1900, and they had two sons, Robert and Thomas. Tip Top Cannery, shown below in an early photograph, remains in the Timmer family today. (Both, courtesy of Claire Timmer.)

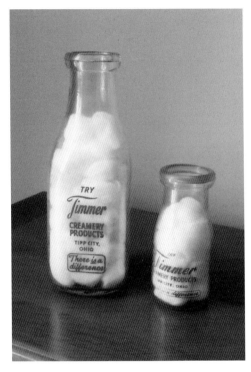

Busy Man

Thomas Gerhart Timmer was born in 1911 to Pete and Lota Timmer. He was small for his age and was called "Little Tommy" until he grew and had enough of it! In 1930, he bought into the cannery operations and considered it his first love, but he was always on the lookout for business opportunities. He bought the Amole Soap building next door to Tip Top and, at the same time, bought Huffman Creamery on the corner of First and Main Streets. The Timmer Dairy delivered milk and cream to most of the homes in town and modestly claimed to make the "best homemade ice cream for miles around!" Timmer's wife, Rose, did the Monday collections of monies owed by the housewives. She was teased about how long it took her to make the round because of all her visiting with friends on the route. A few years later, Thomas Timmer sold the creamery and tore down the Amole Soap building to erect a warehouse for the cannery. Timmer was happiest working in his garden, but he still found time to be the treasurer of the Methodist Church and to serve on the boards of both Monroe Federal Savings & Loan and the Miami Citizens Bank. With his good friends John Holtvoight of Dolly Toy and Dr. Maynard Kiser, they created the first subdivision west of town. At that time, Miles Avenue was the westernmost edge of Tipp City, so the new development was named Westedge. It was designed with inexpensive houses for young working people and their families. Streets were laid out, and two trees per lot were faithfully planted in the front of each house. The next project of Timmer, Holtvoight, and Kiser was to build a municipal swimming pool just east of the City Park, next to the football field. The city fathers were reluctant to support the plan at first, but with the promise that the city could pull water from an aquifer under the Timmer farm, the pool was opened. After Tom developed asthma, he and his wife, Rose (left), spent much of their time in Florida. Thomas Timmer died in 1995 at the age of 82. Continuing the Timmer tradition of supporting the community are grandson Matt, vice president of Tip Top, and his wife, Claire, who serve on the Tipp Foundation. Both say, "Giving away money [to worthy causes] is fun!" (Left, courtesy of Claire Timmer; right, photograph by author.)

Photographer
Thomas "Tommy" Crook, born in 1869, was fascinated by the new science of photography. After studying in Dayton, Crook (above) and his wife, Savillia (below), moved to Tippecanoe in 1906 and set up their studio. The town was growing, and companies used photography to promote their businesses. Families also desired photographic portraits, which were cheaper and faster than sitting for a painting. The Crook Photography Studio, located beside the Crooks' house east of the canal, was flooded out in 1913. As a result of the flood, 14 houses in the floodplain were moved to locations in town, and Crook's studio became someone's garage. Tommy and Savillia are buried in Maple Hill Cemetery. Thomas Crook's now-antique photographs continue to tell the story of life so many years ago. (Both, courtesy of Ray Trucksis.)

Those Who Brought the News

There have been numerous weekly newspapers published in Tippecanoe and Tipp City, starting with the *Tippecanoe City Reflector* in 1854, with editor Charles Hudson and his typesetter, Joshua Horton. The *Tippecanoe City Item* began publishing in 1860. A yearly subscription cost $1. It was "an intelligent paper, devoted to news, literature, science, agriculture, and general intelligence," but it only lasted one year. In 1869, Horton was riding on a train bound for Piqua when John Ford, owner of the Tippecanoe Wheel Works and several distilleries, suggested that Horton publish his own newspaper. Ford said that Tippecanoe was growing and that it could support a worthy newspaper. A month later, Horton was standing on the corner of Main and Second Streets on a dry-goods box, offering free copies of the first edition of the *Tippecanoe City Herald*. A yearly subscription was $2. In the 1880s, Horton retired, and his son, Harry, took over until his death in 1896 at age 39. Harry's son, Ramon, was only 17 at the time and still in school, so Harry's sister-in-law, Nellie Herr Smith, assisted Mrs. Frances Herr Horton in printing the paper until Ramon was older. Nellie Smith is seen here at left with Guy Kinna and Nettie Booher. Ramon's interests were not in the publishing business, however, and he soon accepted a job as a rural letter carrier. The family could no longer continue the paper, and it was sold to different buyers until 1912 when Elmer and Helen Langley purchased it. During the Depression, the price of a subscription was $1.50, but they also accepted three bushels of wheat as payment. In 1937, the widowed Helen Langley sold the paper to Clayton and Helen Finch (see page 33). In the 1960s, the Finches retired and sold the paper to Bowling Moorman Publications, with Vernon "Jack" Bowling as publisher. The paper was sold twice in the 1990s before publishing of the *Tipp City Herald* was suspended permanently in 2008. The *Herald* had provided news in Tippecanoe and Tipp City for 139 years. Another paper, the *Independent Voice,* was published for five years until it ceased in 2009. Stepping in to fill the void were Mike Jackson and Tara Dixon-Engel with the *Tippecanoe Gazette*. After two years of ownership, the *Gazette* was turned over to KBA News in New Carlisle, which continues printing it today.

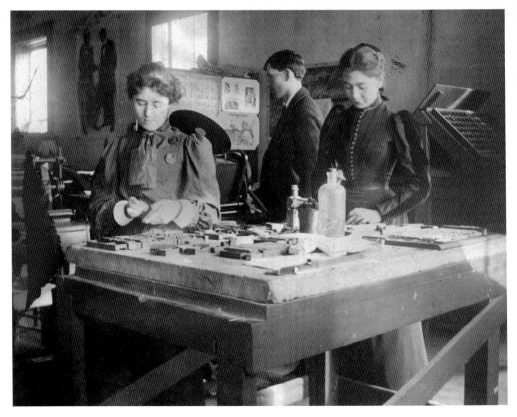

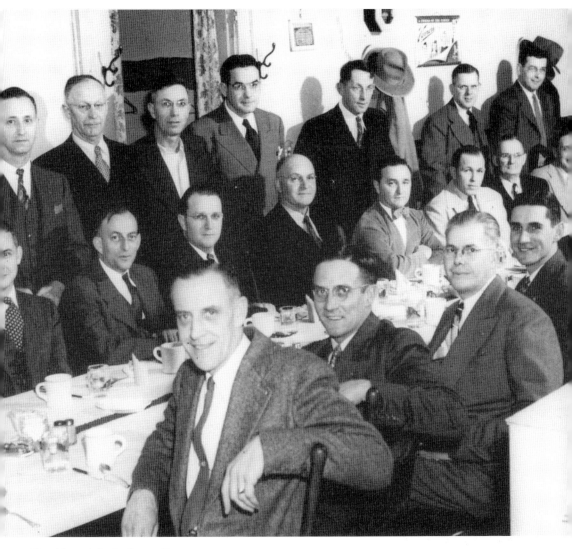

He Would Only Bet a Penny

Clayton "Penny" and Helen Finch lived and worked in Miami County, Kansas, before looking for a small-town newspaper to own and run. Their search led them to Miami County, Ohio, and the *Tipp City Herald*. In 1937, they bought the paper from Helen Langley, who was retiring. The Finches expanded the paper from four pages to eight and ran it for 31 years in several locations. Clayton got his nickname because he loved playing cards at the Thistle Club, and his opening bet was always one penny. In 1944, on the 75th anniversary of the *Herald*, someone sent a congratulatory cake to Mayor Glenn E. Frye, who delivered it to the newspaper office. Helen immediately invited local merchants to an impromptu celebration. In this photograph, Clayton Finch (third from left in the front) attends the fire department dinner in 1942.

Reporter for 40 Years
Rhoda Hausfeld, shown seated on the left, began her newspaper career in 1954, writing human-interest stories for three newspapers, including the *Tipp City Herald*, where she was associate editor for 28 years. Vernon Bowling, publisher of the *Herald*, said, "She could take a simple quote and turn it into a column that gripped the heart of the whole community." Hausfeld was recognized for her extensive volunteer work by Ohio governor George Voinovich, was grand marshal of the Tipp City Mum Festival in 1992, and was presented with the New Carlisle Sertoma Service to Mankind Award in 1993. At her retirement at age 82 in 1996 (below), Hausfeld (center) said, "From just a 'society editor' . . . I learned the intricacies of attending many meetings . . . which make this busy city what it is." (Left, courtesy of Barbara Hartley; below, courtesy of Karen Olshawsky.)

He Could Grow Anything

Peter Bohlender was born in Bavaria in 1838 and immigrated to America. He had a knack for growing plants, so, after learning the nursery trade, he went into business for himself. In 1889, Bohlender's Nursery moved from Dayton to Tippecanoe. His German name aroused suspicion at the start of World War I, so the nursery's name was changed to Spring Hill, inspired by a hill located across the creek on the property. It was largely a wholesale garden store until the 1930s when 70 percent of its nationally known business transitioned to mail order. Spring Hill continued in business until 1977 when it was bought out. It now operates as a mail-order and Internet business. Shown here are some of the Spring Hill chrysanthemums that inspired the annual Mum Festival, which began in 1959. (Courtesy of Natalie Young.)

LEGENDARY LOCALS

He Built Dolly Toy

Henry B. Holtvoight started his business in Dayton in 1923 as Dolly Folding Kite. It did not prosper, so Holtvoight began making toys out of laminated boxboard. In 1936, he purchased property on North Fourth Street in Tipp City and expanded his product line as Dolly Toy, becoming the world's primary supplier of novelties. During World War II, Dolly Toy also made military components from boxboard. After the war, John Holtvoight, son of Henry, took over. A Dolly artist, Phil Riley, designed Mother Goose Pin-Ups, popular wall decorations for nurseries and children's rooms. Shown here are a well-loved growth chart (left) and a wall hanging (below). John Holtvoight also worked with Tom Timmer and Maynard Kiser to develop Westedge and the city swimming pool. In 2008, competition from labor markets overseas forced Dolly Toy to close its doors. (Both photographs by author.)

A Lady with Style
The Topper Dress Shop, located in the Township building on Main and Third Streets, was owned by Cora Scholl and sold women's clothing. Her niece, Eva Wolfe Fleischer, a 1945 Tipp graduate, remembers Scholl always on the lookout for high-class inventory, going as far as Cincinnati to buy from clothing wholesalers. Scholl was also a generous supporter of the Band Boosters, which bought uniforms and instruments. (Courtesy of Eva Fleischer.)

She Knew Every Woman's Dress Size
Bernice Maddux took over the Topper Dress Shop in 1959 after Cora Scholl moved to Florida. Maddux, who knew the dress size of almost every woman in town, had her busiest time at Christmas, a result of husbands not shopping until Christmas Eve. They knew that Maddux would have prewrapped gifts for them to pick up. After retiring, she still received calls asking for suggestions on what to buy. (Courtesy of Gene Maddux.)

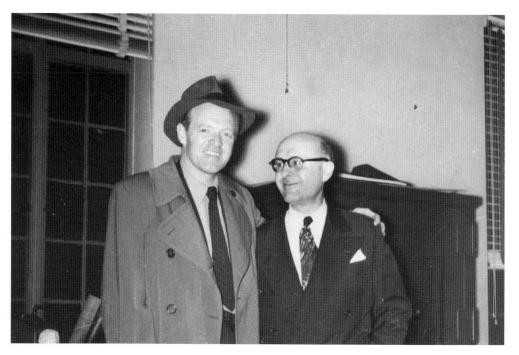

He Ran the Last Picture Show
The last movie theater in Tipp City was located in the Monroe Township building. It was managed by Ray Frisz and his sister, Lee. Ray Frisz said, "The theater was owned by the township, and the terrible fifties finished us. No one went to the movies then." He was also a movie distributor, and he is shown here with Van Heflin (left), a film star of the 1940s and 1950s.

Inventor
Dale Smith graduated from Tippecanoe High School in 1961. He went on to make radar speed detectors for the police. However, when he was unfairly ticketed for speeding, he invented a radar detector in 1968 known as the Fuzzbuster, which sounded if police radar was in use nearby. The oil crisis in 1972 called for reduced speed limits, and the Fuzzbuster became very popular. Similar units are still sold worldwide.

Owner of the First Supermarket
His name was Joseph Elwood Dorsey, but he always went by "Bill." He owned a grocery in the front room where Harrisons Restaurant is now, but in 1948, he built the first self-serve supermarket on Second and Dow Streets. Customers could shop at their own pace using carts. Dorsey's Super E Market was about 4,000 square feet, making it four times bigger than any store in town. It featured a shelving device called a Food-O-Mat that let canned goods roll into place when the bottom can was removed. Dorsey also used a NCR cash register, which replaced cashiers adding up bills by hand. During the grand opening weekend, he served 1,700 customers! After 48 years in the grocery business, Dorsey retired in 1979 at age 80. He is pictured here with his wife, Margaret. (Courtesy of Bill and Caroline Dorsey.)

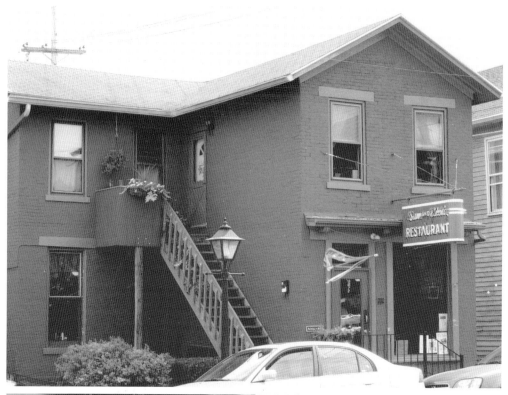

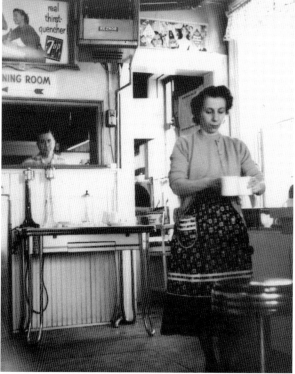

Running a Hometown Restaurant. Sam and Ethel's is the kind of restaurant that can only be found in a small town, a family-owned gathering place serving homemade fare. The eatery had several previous owners and retains the qualities of many earlier diners. Sam and Ethel Moore (left) bought the building, which was over 140 years old, in 1956. It became a local favorite. It is open from 6:00 a.m. to 8:00 p.m., and the breakfast crowd meets every morning when the doors open. When Sam was alive, it closed for two hours in the afternoon so he could take his nap. The regular menu features specials every day. When Ethel made her authentic Italian lasagna, people lined up into the street, hoping to get their meal before it was all gone. The restaurant is now owned by Keith Long. (Courtesy of Keith Long.)

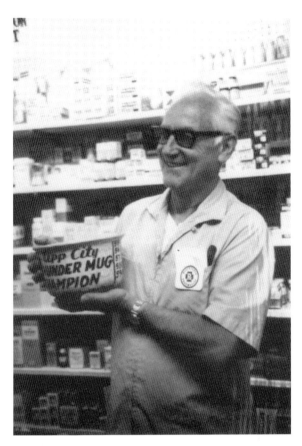

Well-Loved Pharmacist
Ross Smith never intended to become a pharmacist in Tipp City. He wanted to be a teacher and coach, but his father, who was superintendent of Tipp City Schools at the time, would not pay for his college if he studied education. So Smith changed his major at Ohio Northern to pharmacy. Smith, an excellent athlete, also considered a career in professional baseball, but his wife, Evalyn, disapproved. So, after college, Smith went to work in a drugstore owned by his father, across the street from Sam and Ethel's Restaurant, earning $25 a week. This was during the Depression, and despite being open thirteen hours a day, seven days a week, the store did not do well. The Smiths struggled financially until they bought a drugstore in Springfield for $4,000. For four years, the Smiths worked there, but they missed Tipp City and all their friends, so they bought a drugstore in Tipp. The hours were still long and involved a six-day workweek, but this was the life they wanted. Smith was renowned for playing pranks, telling tall tales to entertain his friends, and for rearranging the shelves in his store. He said he did this so that customers might find something new to buy while they were looking for what they had come in for, but most people thought it was one of his pranks. A couple of times, Smith even gathered some of his friends and, in the middle of the night, carried the soda fountain counter out into the street, turned it around, and put it back on the opposite wall. He loved golf and, with Ralph Rodenberg, started the Thunder Mug Tourney, which continues today as the Tipp Open. The Thunder Mug trophy was a bedpan filled with beer and inscribed with the names of all the participants. Smith's Merry Open, which became the Snowflake Open, was played at Homestead Golf Course in January, with Smith hitting the first shot off the snowy tee. His drive went eight inches! He sold the drugstore in 1963, preparing to retire, but he missed spending time with the customers so much that he bought it back. He finally sold it for good to Bill Wilhelm in 1972 and retired to travel with Evalyn, play cards, and golf with his many friends. (Courtesy of Dr. Charles Smith, DDS.)

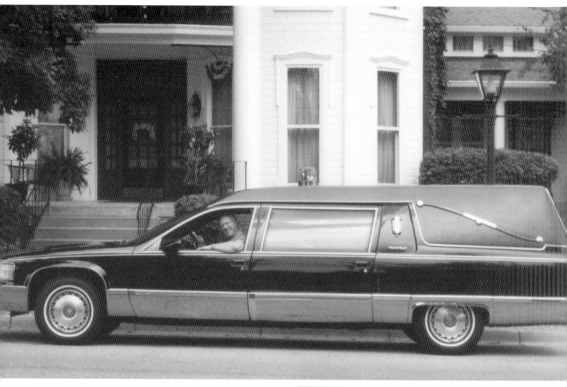

He Wants to Make It Easier

The Frings and Bayliff Funeral Home, owned by Jim Bayliff, is in a historic house on the corner of Main and Seventh Streets. Bayliff's father and his brother also own a funeral home. Handling a family's grief is not easy, but Bayliff's philosophy is to "be strong and make it a little easier for them." He attended Cincinnati College of Mortuary and came to Tipp City to work with Otto Frings, taking over the business when Frings retired. He typically does 100 funerals a year. Bayliff said, "This is more than a business. It's a personal commitment." His daughters Lauryn and Leigh Ann have come into the business, which he hopes to someday turn over to them, continuing the family tradition. In the above photograph, Bayliff is seen in a classic hearse. At right, Leigh Ann is pictured at her mortuary school graduation with her father. (Courtesy of Pam Bayliff.)

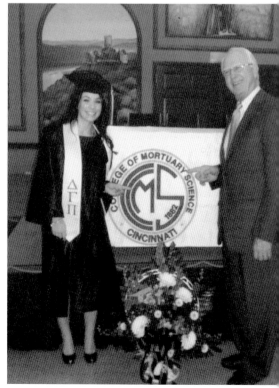

CHAPTER THREE

Educating for the Future

A history of Tippecanoe written in the 1880s states, "While the place [Tippecanoe] has much reason to boast of the rapidity with which so many improvements have taken place in her corporate limits, as well as the convenience of her business facilities, there is nothing for which she deserves greater praise, or for which she should be more highly lauded than the thoroughness of her public schools." This well-deserved praise for the Tippecanoe schools continues today.

Hyattsville's first school was on Springfield-Greenville Road, which is now Main Street. Not to be outdone, nearby Tippecanoe soon followed with its own school east of the canal. In 1853, the first board of education was elected. The following April, a tax totaling $3,000 was levied on property owners, with the city fathers going door-to-door to collect it. The tax would cover the cost of a new building and an instructor to teach three months plus three weeks after harvest season for the next several years. Class sizes were enormous in those days, often with 65–80 children of all ages crowded into the one room. One of the first teachers was a young man by the name of Gilbert who afterward became a physician. Another, John McPherson, taught for $75 per term until his pay was reduced to $60, and he transferred to the Hyattsville school, which paid better.

Over the years, the Tippecanoe schools were housed on different sites to accommodate the growing population, until 1868 when land was purchased from Jacob Rohrer for $2,000, and the elegant three-story brick structure called "The Castle" was built. In 1878, its first graduating class of four students received their diplomas.

Along with each new school building were teachers who were eager to use the most up-to-date educational techniques. Teachers like Bella Brump in the late 1800s visited other schools and took classes to make sure that Tippecanoe students benefited from the latest innovations. James Bartmess was superintendent in Tippecanoe for over 20 years, starting in 1875. Despite the controversy, he abandoned the one-room school concept and placed students in classrooms according to age and ability.

The high school built in 1917 was considered the most modern of its day, and it was followed in the 1950s and again in the 1960s with additions of a gym and a stage, a cafeteria, and an elementary building. Since that time, another elementary school has been built, followed by a junior high building, another high school, and, recently, the newest high school.

People in the forefront of Tipp City education have included L.T. Ball, Nevin Coppock, Anne Keppel, and Stewart King. This tradition of progress and growth continues with today's dedicated teachers and administrators.

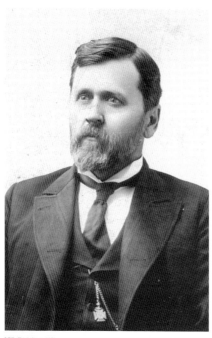

Innovative Superintendent

At age 17, James T. Bartmess enlisted as a drummer boy during the Civil War. He was captured twice and spent time at the infamous Andersonville Prison. Upon his return, he found his calling in education, not saddle-making as his father wanted. Bartmess was superintendent of the Tippecanoe schools for 21 years, introducing many progressive and controversial innovations, including elimination of one-room schoolhouses.

Progressive Teacher

Clara Belle Brump (second row, center) taught for 30 years in Tippecanoe. She was known for being progressive, striving to be "alive to the influences of progress . . . always an advocate of reform." She had a wooden hand, which she used to thump unruly students on the head. By 1922, she had married and moved to Florida, becoming Mrs. Belle Dolan. James Bartmess is in the first row, center.

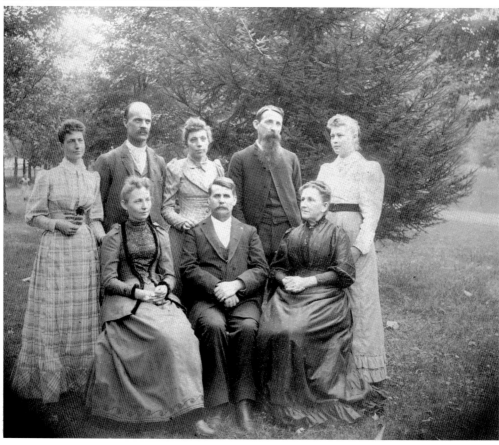

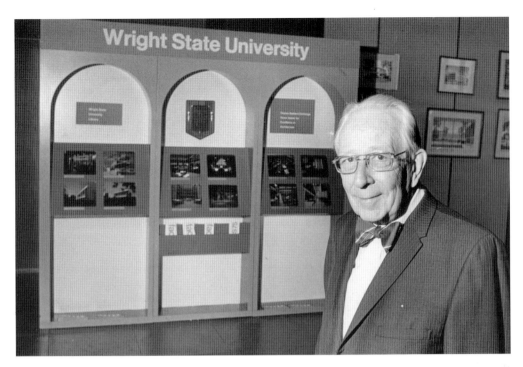

Father of Wright State
Fred White is called "The Father of Wright State University." He began his career in education, but then worked at General Motors for 20 years. In 1962, he looked for a way back into education, and within a few months, White was the first employee of what would become Wright State University. As business manager, he supervised the acquisition of land and the construction of the first four buildings (below). White took pride in his insistence that Wright State be completely handicap-accessible, ignoring criticism that called the weatherproof tunnels "White's Folly." A WSU medical school was also his dream. After his death in 1980, ground was broken for the Frederick A. White Health Center. His family quips, "Fred is the only guy we know without any money, but who has a building named after him!" (Both, courtesy of Ruth Ann White.)

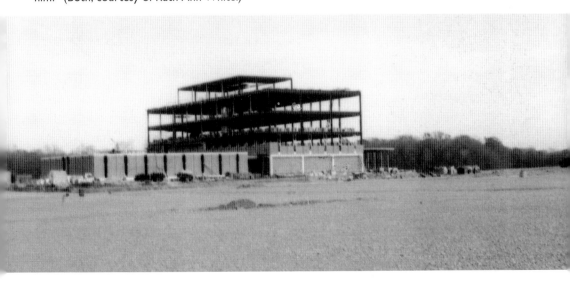

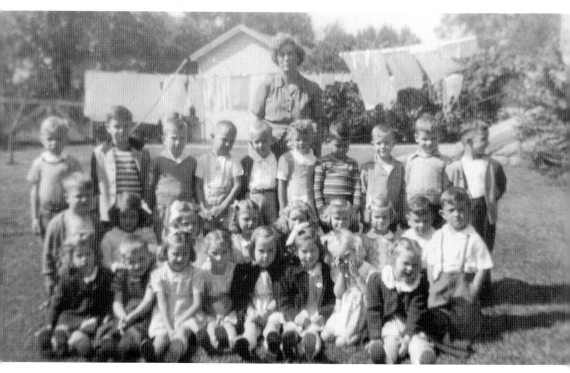

First Kindergarten Teacher

Fred White's wife, Ruth, was also a well-known educator. In the 1940s, kindergarten was unheard of in Tipp City until Ruth opened one in her home on Main Street. She is shown here in her backyard with her class. White had many stories about her classes, including one in which a child locked himself in the upstairs bathroom and the fire department had to rescue him via a ladder up to the bathroom window. A taxi driven by Mary Belle Fry picked up children at their homes and took them to White's house for $1 a week. Everyone remembers Fry's long red hair blowing out the window as she drove. Under the direction of Supt. L.T. Ball, White began teaching her classes at Broadway Elementary in 1952, with 65–75 children in each morning and afternoon class. (Courtesy of Ruth Ann White.)

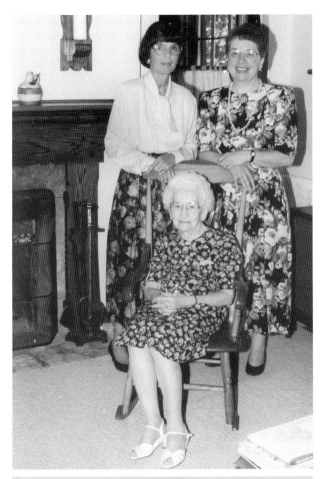

Tradition of Education

Ruth Ann Jackson married Bob White, Fred and Ruth White's son, and became a kindergarten teacher, working with the first Ruth White at Broadway Elementary for many years. The tradition of education in her family began with Clio Wooley Lucas, Ruth Ann's grandmother who taught in a one-room school. It continued with Thelma Lucas Jackson, Ruth Ann's mother. Jackson is shown seated in the above photograph with Ruth Ann (left) and her sister, Sue Myers (right), also a teacher. The two kindergarten-teaching Whites then inspired daughter Cathy White Drake and granddaughters Julie Drake Berning (below, right with White) and Katy Badgley Wiggs to also teach. Wiggs now teaches kindergarten online in South Carolina. The progression from a one-room schoolhouse to school on the Internet shows how much education has changed and how far, from kindergarten through college, the White educational legacy extends. (Both, courtesy of Ruth Ann White.)

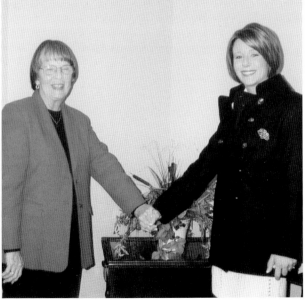

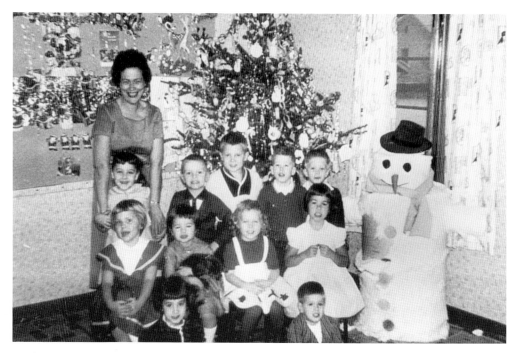

Play School in Her Home
Florence "Bettie" Jackson Staup started the first preschool in Tipp City, the Jack & Jill Play School, in her home on Seventh Street. From 1953 to 1967, it met four days a week from 9:00 a.m. to 11:00 a.m. for a weekly fee of $2. Staup was also a member of numerous local clubs, was cochairman of Tippecanoe High's first band camp, and served on the early Mum Festival committees. (Courtesy of Joan Staup Pearl.)

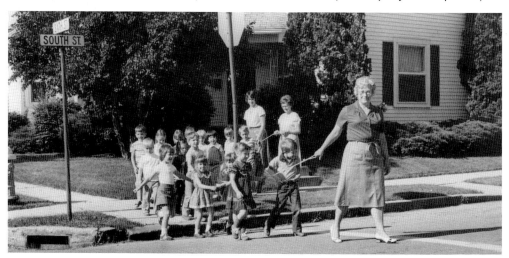

Nursery School on Her Porch
Rita Seybold started the Little Gray House Nursery on her back porch in 1965. Her motto was "Children Learn by Doing." She created her own curriculum after talking to elementary school principal Ron Martin about what children needed to be successful in kindergarten. Seybold invented the "Walking Rope." By tying smaller loops at intervals on a longer rope, she could safely take her class on walks around town. (Courtesy of Amy Ignet.)

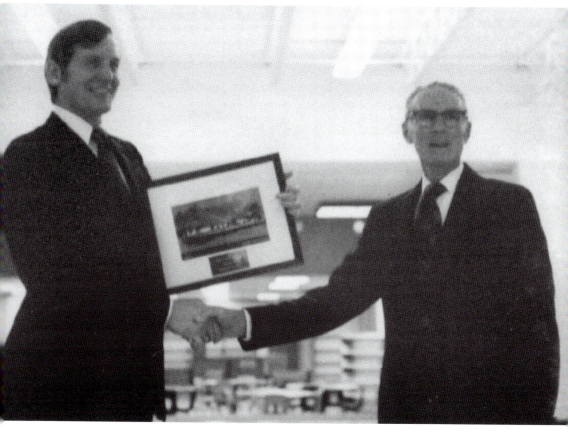

"Good Schools Don't Just Happen"

Leonard Terry "L.T." Ball was born in 1894 in the hill country of southeastern Ohio. His parents worked hard taming the hardscrabble land, and they valued education for their children. Ball first attended public school in 1900, but several times over the years he had to drop out to help on the farm. He finally finished high school in three years in 1915 and graduated at age 21. With a laugh, he said, "I finished ninth in my class, but lest that statement be misinterpreted, there were only nine in the class!" He left for Ohio University with $44.50 in his pocket and took an assortment of jobs to pay his tuition and support himself. After joining the Air Force in 1918, he qualified for a teaching certificate and began teaching in Kansas. By Thanksgiving, he had been promoted to high school principal. He returned to Ohio two years later and took a job as principal at an elementary school in Utica, where he met and married Mabel Barrick in 1926. Returning from his honeymoon, he was overjoyed to learn that his salary had increased to $1,200, and he could earn an additional $400 if he also took the custodian job. Ball eventually earned his BA degree in 1931 and his MA in 1939. After working for Utica Schools for 23 years, 13 of them as superintendent, Ball got a call from the Tipp City Exempted Schools in 1946, and he started as superintendent in August. He took over during a time of conflict for the schools, but with a vision and a policy of cooperation, Ball began a building program, adding Broadway Elementary, Nevin Coppock Elementary, and a high school that was completed in 1964. He also restored curriculum, added vocational classes, revived the Future Farmers of America, introduced a work/study program, and upgraded the teaching staff. He introduced public kindergarten classes and an ungraded primary level that allowed students to work at their own pace. His slogan was "Good Schools Don't Just Happen." After 18 years, L.T. Ball retired. He said that "the greatest compliment of all was the honor of having the new Middle School named for me in 1974." Here, Ball (right) accepts that honor from school board president Jim Kyle. (Courtesy of Kari Prall.)

Honored with the Name of a School
Nevin Coppock was president of the Tipp City School Board when he died in May 1959 of paralytic polio. Mass polio vaccinations had begun, but not in time to prevent his death. It was said that "his life was one long record of service to others." Coppock farmed 300 acres and milked 35 cows. His obituary said, "We wonder how he found the time to farm on such a scale and keep up with the work he did for so many organizations." In his honor, the school board named the newly completed elementary building Nevin Coppock Elementary. Coppock farmed land between County Road 25A and Evanston Road that was deeded to his ancestors in 1813 by Pres. James Madison. At the western edge is Coppock Woods, land donated to the schools for an outdoor nature lab. (Courtesy of Nevin Coppock Elementary.)

 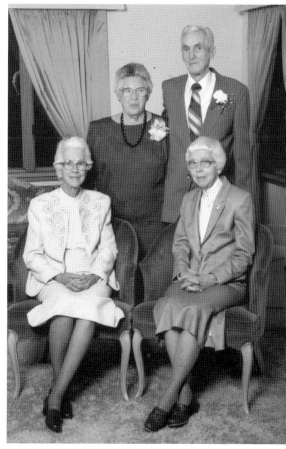

Unforgettable English Teacher

Mary Kyle Michael, a longtime English teacher, wrote a poetry book in which she said, "I had tried secretarial work, writing radio continuity, and accounting, all interesting, but not quite satisfying. Finally I came back to Tipp City to teach English at Tippecanoe High School. Teaching was my hardest job, but it gave me delight in a blue jay feather." Michael prepared her students for college English, even though she was a bit eccentric. In the fall, she pinned a different leaf on her dress every day. Students chuckled behind her back, but they never doubted her ability to teach. She had a catchphrase: "Suppose you look that up." Michael graduated from Tippecanoe High School in 1919 (left). In the right photograph, she is seated at right. Posing with her are her sister Betty (seated, left), brother Thomas Kyle Sr., and his wife, Helen.

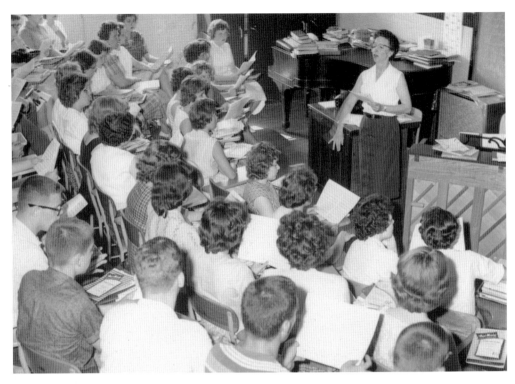

Gift of Music
Ann Keppel was a talented and highly respected vocal music teacher for many years at Tippecanoe High School. Despite her failing eyesight, she found her way around the school easily, and she could readily recognize people by the sound of their voice or even their laughter. Always independent, she learned Braille before her eyesight vanished and put it at the top of all her sheet music. It took only seconds for her to pick out exactly the piece she wanted. Choir rehearsals always started with vocal warm-ups designed to loosen the throat and lips. Every student who ever sang for her remembers, "Dah Mae Nee Po To La Bay," "Nee Ah Nee Ah Nee," "Mae Mei My Mo Moo," and finishing with "Morning Winds Among the Lindens Moan and Murmur in the Morn."

Concerts
All Ann Keppel choir concerts were divided into three parts. One segment consisted of contemporary songs, during which the students performed in white shirts and dark skirts or pants. A second was religious music, performed in robes. The third section was presented in party dress. Soloists or ensembles sang between sections while the others changed clothes.

Loving Tribute

At an event honoring Ann Keppel, a loving tribute came from Claudia Huntsberger Rogers, one of the many teenagers who had been introduced to the gift of music in Keppel's choir. It begins, "Once upon a time, there was a sad young girl. Her father was terminally ill. . . . The girl had a great love for music, a gift she received from a beloved music teacher, so she decided her gift to her father would be to organize a mini concert complete with costumes and props. . . . The time came for the girl to perform. She sat down in front of her father, looked directly into his eyes, and sang just to him. Her father held her and said her song was the most precious gift he received. He called her his 'Song Bird' until the day he died. Music, the gift given by a wonderful, loving, kind, talented music teacher has blessed the girl's life in countless ways. . . . That girl was me."

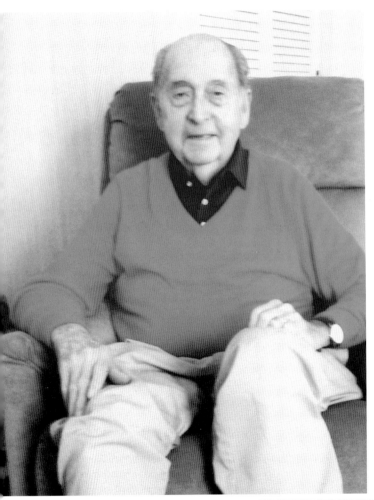

The Script Tipp

Stewart King was raised on big band music, and he plays the saxophone, flute, and clarinet at a professional level. He graduated from Capital University in 1951, enlisted in the Navy, and was sent to the Naval School of Music in Washington, DC, where he played at Pres. Dwight Eisenhower's inauguration. After L.T. Ball hired King as the band director, he grew the band from just 35 players to 160. He also started the tradition of band camp in the summers. The Ohio State University Marching Band's signature formation, Script Ohio, inspired King to design Script Tipp for his band (below). Since retiring as principal at Tipp Central in 1985, he has directed the Zion Lutheran Church choir. King also judged bands at Ohio Music Association contests for over 50 years and played with several area concert bands. (Above, photograph by author; below, courtesy of Stewart King.)

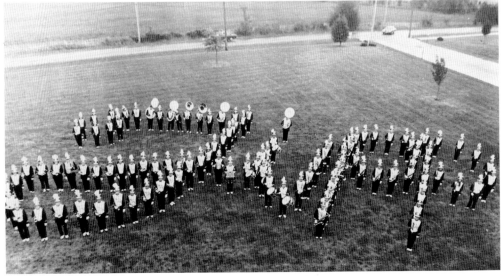

52 Years of Teaching

Mary Elizabeth Prill Butler, shown standing left with the white collar, was born in 1907 in Tippecanoe, and memories of her still live in the four generations of children she taught. Inspired by her own eighth-grade teacher, Butler attended West Milton Country Normal School after high school to get her teaching certificate. Her first job was in a one-room school on Kessler-Cowelsville Road, for which she was paid $800 per year. That first class was notoriously unruly. Realizing the need to establish herself, she picked up a baseball bat from the playground and very authoritatively laid it across her desk. When asked what the bat was for, she replied, "You never know what a bat could be used for." The lessons began and continued without any trouble, and at recess she played baseball with her students. When Butler was 36, she married widower Basil Butler and became an instant mother to Basil's young daughter, Barbara. In 1947, the couple bought a variety store in the Chaffee Building on the corner of Second and Main Streets, which later became the Butler Building. The store was famous for its penny candy. Many children saved their pennies so they could peruse the sweet choices and buy exactly what they wanted. Butler was widowed in 1967. In her 52 years of teaching, she worked under seven different principals and mentored 11 student teachers. She was known for having the students march around the room as they repeated their multiplication tables. In 1961, she required complete silence as they listened over the PA to Alan Shepherd's launch as the first American into space. In the late 1960s, she bought a yellow Cadillac convertible. Not only did she love Cadillac cars, they were also one of the few automobiles that allowed her to pull the seat far enough forward so her feet could reach the pedals. She never did learn to put the top down because she did not want to mess up her hair. In the mid-1970s, Butler joined with several other teachers to request that the superintendent allow them to wear slacks to school. The request was granted, and the next day she wore her first pair of slacks to work. Retiring in 1978, she devoted her time to her store and to many community organizations. In 1985, she was voted Citizen of the Year.

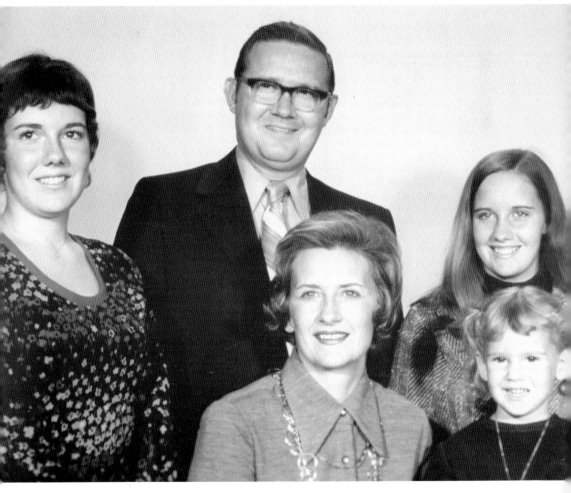

The Doctor and the Principal
Dr. Albert and Adrienne Howell came to Tipp City in 1965 when Albert joined the medical practice of Drs. Morlidge and Pyles. In 1969, he led a successful school levy campaign and was elected to the board of education, serving two years as its president. He was also the Tippecanoe athletic team physician before dying at age 41 in 1976 after a lengthy illness. Adrienne, an experienced teacher, taught for several years in the Tipp district before being appointed the first woman head principal in the Tipp City Schools, at Nevin Coppock Elementary in 1979. She said, "Tipp City has always been a conservative community, but the board had the insight to move forward with women in administration." In this family portrait, Adrienne and Albert pose with their three daughters, Evonne (left), Gwen (center right), and Allison (lower right). (Courtesy of Adrienne Howell.)

CHAPTER THREE: EDUCATING FOR THE FUTURE

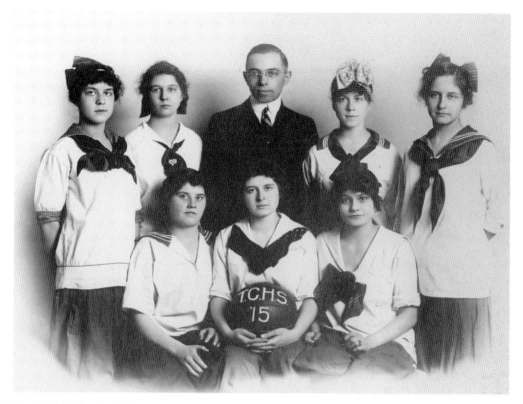

First Girls Basketball Team
Pictured here is the first girls basketball team at Tippecanoe High School, in 1915. The team manager is chemistry teacher Mr. Crist (second row, center). Leota Hoover is holding the basketball. For practices, the girls played on a court laid out under the trees. They played girls teams in Greenville, Germantown, Sidney, and Piqua at the Opera House where the court was marked off on the floor.

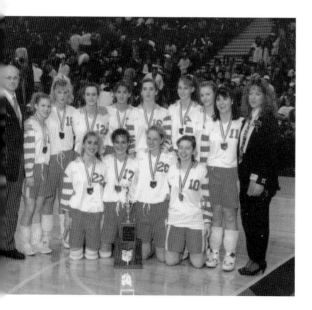

Volleyball State Champions
The girls volleyball team at Tippecanoe High School made history in 1992 with a second-place finish at the state tournament. The players had no tournament or invitational experience, but they advanced to the finals with a 23-2 record. Coach Tom Rogers (standing at left), who coached two of his daughters, said, "This is a fantastic experience for all of us, and every step we take is history." (Courtesy of Tom Rogers.)

LEGENDARY LOCALS

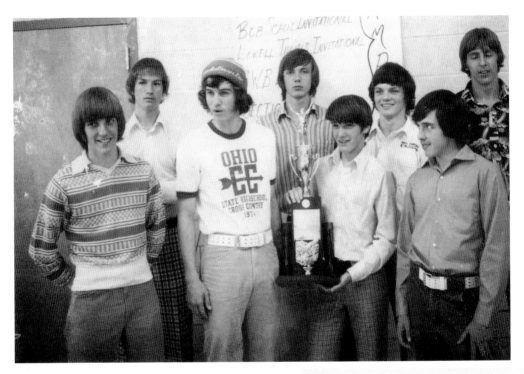

Cross-Country State Champions
The boys cross-country team of Tippecanoe High School ran its way to a second-place finish at the state championships in 1974 and again in 1975. Coach Tom Rogers's unorthodox training methods, like running up the bleachers or on the levy and doing speed drills, made the boys ready for competition. Both years, this Division AA team won all its races except one. (Courtesy of Tom Rogers.)

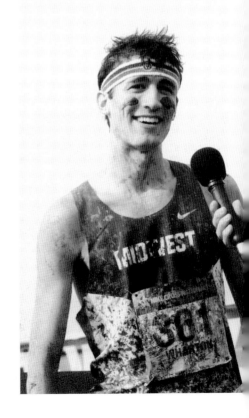

State Champion Runner
Sam Wharton's running career at Tippecanoe High School is unmatched. Wharton represented Tippecanoe at the state championship level eight times, winning the individual title in both cross-country and track in 2013. He also won the Nike Cross Country National Championship (shown here). In track, he competed at the national level, earning All-American honors his junior and senior years. He attends Stanford University. (Courtesy of Kim Wharton.)

58

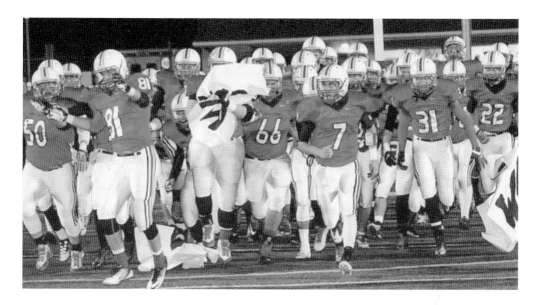

History-Making Football Team

The 2013 season was a red-letter one for the Red Devil football team. For the first time in the school's history, the football team made it to the regional championship playoffs, following a 12-0 season. With their victory over Thurgood Marshall (below), Coach Charlie Burbagher said, "They hung in there and they played hard. They stuck to what we've been doing all year." Although they lost in the next round of play against Trotwood, Burbagher said of his players, "The kids played like they deserved to be here. They worked hard . . . and they didn't disappoint." The team was also honored as the National Guard JJHuddle Ohio Football Team of the Year. (Courtesy of Carla Ungerecht, editor of *Tippecanoe Gazette*.)

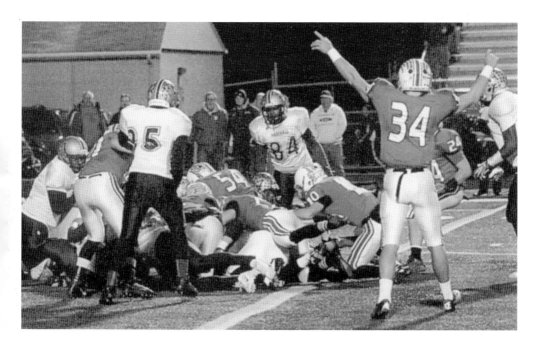

Longtime Coach
Allen "Alkie" Richards coached football at Tippecanoe High School and at Troy High School for over 30 years, teaching science, then working as a guidance counselor and athletic director. He was inducted into the Ohio Athletic Director's Hall of Fame in 1983. He was an outstanding athlete in football, basketball, and baseball in high school at Miamisburg and in college at the University of Cincinnati. Richards earned 16 varsity letters during his college career, despite it being interrupted by World War II when he served in the Marine Corps. He was invited to join the Chicago Bears after graduation but declined the offer and chose to go into education. He was also inducted into the Cincinnati Bearcat Hall of Fame in all three sports in 1985, an unmatched accomplishment. (Courtesy of the Troy Historical Society.)

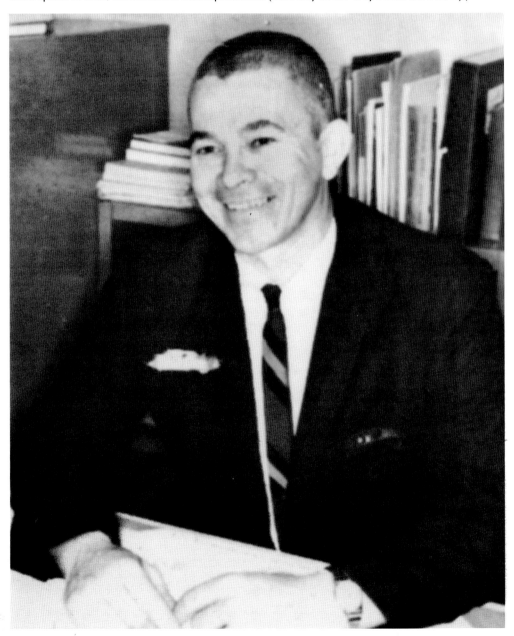

CHAPTER FOUR

The Families behind the Street Names

The first road to bear a pioneer's name was Hyatt Street, self-named by Henry Hyatt, who founded the town of Hyattsville. Hyatt Street runs north and south and crosses Main Street, formerly Springfield-Greenville Road. Numerous other streets and roads in and around Tipp City have been named after legendary local people and families. Many of the early named roads were located along the border of the farm owned by that person. When a road was improved or newer housing was built, the road was often renamed in honor of a family that had an influence on the town.

Many families braved the wilderness to civilize southwest Ohio and build the town of Tippecanoe. The Bowman family arrived in Miami County after several years of trading with the Native Americans and buying as much land as they could afford. The grandfather of Charles Kiser, Isaac Kiser, was the first white male child born in Brown Township in Franklin County.

The Kerr family came from Ireland before the Revolutionary War, and George Kerr fought with the Continental army. Another Kerr ancestor, Aunt Sallie Thompson Kerr, born in 1800, survived by her wits after being separated from her family when they traveled from Canada to Cleveland, Ohio, during the Indian War of 1812. After being left in the protection of relatives and friends who for various reasons abandoned her, she tried to reach her family for several years. She was then held captive by Native Americans for two years before being released near Piqua, Ohio. She never saw her family again.

The men and women who established their lives in and around Tippecanoe came from this resilient stock, thus earning for themselves and future generations the honor of having streets named after them.

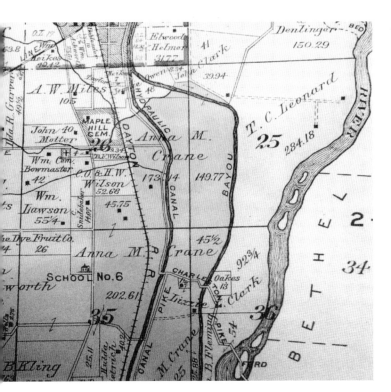
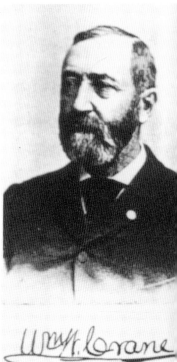

Crane Family and Crane Road

Edward Lewis Crane was born in 1803 in New York. After studying the "doctoring trade," he got wanderlust and walked to Ohio, ending up in Dayton. He set up a practice, but he still loved to wander. While staying at an inn in West Charleston, his horse escaped. Searching for the animal, he came to the Woodard farm where he met the proverbial farmer's daughter, Anna, fell in love, and married her. The couple moved to Tippecanoe. The Cranes celebrated their golden anniversary at the Chaffee Opera House in 1880. Edward Crane, known for his independent thinking, said, "Don't read too much. Be sure you get a clear idea of every sentence you do read and learn to think for yourself." The area of the map (left) labeled "Anna Crane" shows the Crane family farm. The original path of Crane Road served as a link between the stage line on State Route 202 and small outposts to the west. After the canal was built, it connected the village of Cowelsville to Tippecanoe. William Woodward Crane (right) was Edward and Anna's oldest son. He, too, studied medicine. Before setting up his practice, he served in the Civil War as an assistant surgeon, keeping meticulous notes on each soldier he treated, noting their rank, their injury, and the outcome. Dr. William Crane was one of the first people to plant maple trees near the sidewalk in front of the houses in Tippecanoe, "starting a tradition that has since won much admiration for Tippecanoe's beautiful shaded streets." Needing income to support their medical practices, both father and son were also farmers. They became famous for developing a new breed of cattle, the Double Standard Polled-Durham, which is similar to a Shorthorn, but hornless. The breed became quite popular. (Courtesy of Gene Maddux.)

Bowman Family and Bowman Avenue

The Bowman family came to Ohio in 1810 from Tennessee when Joseph Bowman was nine. His father, Jacob, soon died, and Joseph went to live with an uncle. At age 16, Joseph borrowed $2.50 to buy some goods to sell and a basket to carry them in. Selling whatever he could, wherever he could, he eventually went into trade with Native Americans, trading furs and goods along the Ohio River. He bought goods in Cincinnati and hauled them to the Mississinewa River, where he cut down a tree and hollowed it out to make a canoe. He then floated his goods downstream, selling them to Native Americans along the river. During this time, he purchased as much land as his income would allow. At one time, he owned seven or eight farms. Joseph Bowman settled down in Fredericktown in Miami County, married Mary Sheets, and they had 10 children. One of their sons, Joseph Warren Bowman, sold hardware for his father in Fredericktown before owning a grocery in Tippecanoe. In 1866, he became an owner in Bowman, Wells & Company of Tippecanoe, selling dry goods, boots, and shoes. The store was located in the Morrison block on the south side of Main Street between Second and First Streets. It was said that "he displayed the fullest stock of goods in the place, which he sold at lowest prices." Several others joined him in this business until Joseph Warren Bowman bought all of them out and eventually sold the company to Samuel Smith. Bowman's next enterprise was as secretary, treasurer, and general manger of the Dye Fruit Company. He oversaw 160 acres of fruit trees for the company, mostly cherry, peach, and plums. He personally owned 130 acres in Monroe Township. Joseph Warren Bowman was also president of Tipp Whip and was one of the organizers of the Strawboard Works and the Tippecanoe City National Bank. In 1877, he built a home (above) at 327 West Main Street, which is now Frings & Bayliff Funeral Home. The pillars and porch covering were added by later owners. (Below, photograph by author.)

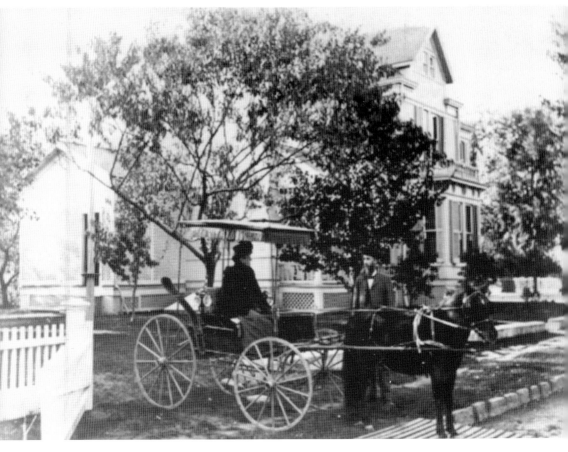

Ahijah Miles and Miles Avenue

Ahijah Miles was born in 1839 near Newton, Ohio. After his father's death, Miles had to work the farm, which prevented him from finishing his education. Despite this, he did two brief stints as a teacher before deciding he wanted to see the country. He started out for Iowa, but when he missed the stagecoach, he decided to walk the 150 miles to Leon, Iowa. He stayed in Leon for a brief time before coming to Tippecanoe at age 19, and he spent his first year here earning his school diploma. He worked in a drygoods store until 1861 when he became the first citizen of Tippecanoe to enlist in the Union army, serving four years, three months, and five days in the 11th Ohio Infantry Company. Amazingly, his only injury during that fighting was a flesh wound on his little finger. After the war, he led the Tippecanoe Militia in quelling a coal-mine riot, and his militia prevented a lynching in Washington Courthouse, Ohio. For 16 years, Miles served as postmaster while also running a confectionary store. During that time, a small announcement in the *Tippecanoe City Herald* reported that both Miles's confectionary shop and the post office had new chandeliers. Miles's motto was "excellence in quality, integrity in transactions, low prices, and quick sales." He served on the school board for over 40 years as well as on the boards of the Tipp National Bank, the Monroe Federal Bank, and as a trustee in Monroe Township. He remained active until the very end of his life, walking downtown almost daily. He loved gardening, but in 1933, at age 94, after planting tulips in his yard, he fell and died the next day. For his funeral, "all forms of civic activity was halted. . . . Flags were at half-mast. Banks and the savings and loan suspended operations at noon, and all businesses closed between three and four-thirty." He is shown here with his third wife in front of the house he built on the corner of Main and Fourth Streets in 1888. It was destroyed by fire in 1988.

Kiser Family and Kiser Avenue

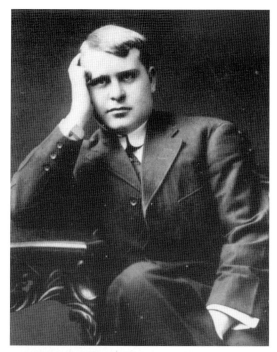

The Kiser name has been prominent in Miami County since the time of the earliest settlement. Isaac Kiser was the first white male child born in Brown Township. Isaac's son, W.I. Kiser, better known as Billy, fought in the Civil War, sustaining numerous wounds. He was called "one of the best known men in Miami County and came within six votes of being elected county treasurer" as a Democrat in a mainly Republican county. That elected office would eventually be won by his son, Charles Kiser, in 1905. Together, Charles and his father owned a busy agricultural implement business. Another son of Billy's, Benjamin, established himself in Fletcher, Ohio, and Ben's son, Foster, was born there in 1886. Foster (above) attended Sterling Medical school and became a physician in Tippecanoe in 1914. He attempted to join the military during World War I, but did not qualify, so he provided service to his country through the Red Cross. Active in the community, he was a member of the city council, the Independent Order of Odd Fellows, the Masons, the Modern Woodmen of America, the Benevolent and Protective Order of Elks, and the Junior Order of United American Mechanics. Foster's son Maynard (below) continued the tradition of doctoring when he, too, became a physician practicing in Tipp City. He served as the medical director for Aero Corporation, Leland Airborne Products, and the A.O. Smith Corporation, along with being director of the Tipp Land Development Corporation. He joined with Thomas Timmer and John Holtvoight in building the Westedge housing development on land he owned at the western edge of town. In 1964, Maynard was named Man of the Year by the Tipp City Chamber of Commerce for his work with Tipp Youth, Inc., the Tipp Citizens Bank, the Miami Valley Council of Boy Scouts, and the Troy Country Club. Dr. Maynard Kiser died in 1969 at age 59. (Below, courtesy of the Troy Historical Society.)

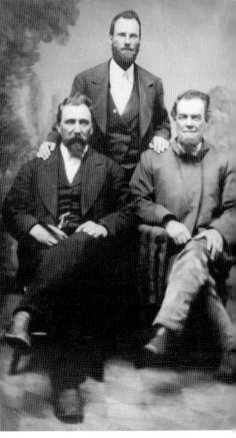

Kerr Family and Kerr Road

The Kerr family came to Monroe Township in the early 1800s when George Kerr "took up raising short horn cattle and Poland China Hogs, which were first bred in the Miami Valley." Posing in the above photograph are Hamilton Kerr (right) and his sons John (standing) and Furnas (left). John owned over 160 acres near Tippecanoe, while Furnas's farm buildings were said to be "the finest in Monroe Township and are second to none in the county." James. A. Kerr (below), son of James T. Kerr, was a farmer who later studied law and was admitted to the Ohio bar at age 23. He formed a law partnership with his brother, Ellis Hamilton Kerr, in 1879 in Tippecanoe, and they later brought Ellis's son, Raymond, into the practice. At that time, Tippecanoe had a population of only 2,000, but it boasted two law firms, all Kerr relatives. Ellis received much publicity during several famous legal cases. One case, *John W. Underwood vs. the Village of Tippecanoe*, regarded the liability of the village for defective streets. In another case, Kerr defended Jefferson Shank, indicted for first-degree murder. The outcomes of both trials are unknown. Ellis also served five terms as mayor of Tippecanoe and four years as city solicitor. (Both, courtesy of the Troy Historical Society.)

CHAPTER FIVE

In Service to Others

Altruism, selflessness, and generosity are sometimes the only explanations for why some people give of their time and talent for the benefit of others. Over the years, many such willing people have emerged in Tippecanoe and Tipp City.

In the early years of Tippecanoe, men and women realized rather quickly that if they wanted their town to change from a wild and rowdy canal town into a civilized place to live and raise a family, a government had to be established. Men volunteered to serve on the council and act as mayor, with their only payment being the thanks of the citizens. This commitment required them to leave their farms and stores at times when it was not easy or convenient. An article in one of the earliest newspapers announced that the council meeting could not start until Thomas Jay closed his shop so that he could attend. Around that same time, the council hired a lamplighter to light the newly installed lampposts along the street so that people could see their way to come to meetings at night.

An urgent need in early Tippecanoe was for a volunteer fire department, as frequent fires threatened to devastate the entire town. Charles Trupp took on this cause, and in 1875, he donated money to build the Tippecanoe City Engine House on Third and Main Streets. The residents also sought to bring cultural events to town, and this became the mission of Sidney Chaffee, the wealthy distillery owner who donated money for the Chaffee Opera House.

The women of Tippecanoe made numerous contributions. The Women's Civic Club of Tippecanoe saw the need for a public library and refused to give up when the idea was first voted down by the city council. If funding was the issue, then the women would find a way to raise the money. They organized fundraisers to pay for books and a librarian's salary, and in 1923, the project was approved. Nellie Herr Smith was one of the many who campaigned for the project, and librarians such as Lulu Cottingham and Catherine Kessler saw it through.

Modern Tipp City also has selfless citizens who have stepped forward to serve their neighbors. The Tipp City Foundation provides scholarships to Tippecanoe High School students, and it sponsors projects that the schools might not otherwise be able to afford. Volunteer fire and emergency squads have been on call for many years and have served well. Local volunteers spend many hours in places like the food pantry and at a secondhand clothing shop called the Clothesline. Others step up to promote school levies and to work in classrooms as unpaid volunteers.

The names of all the people who have given their time for the betterment of their neighbors are too many to list here, and many of them may never be known. But they will always have Tipp City's hearty thanks and appreciation.

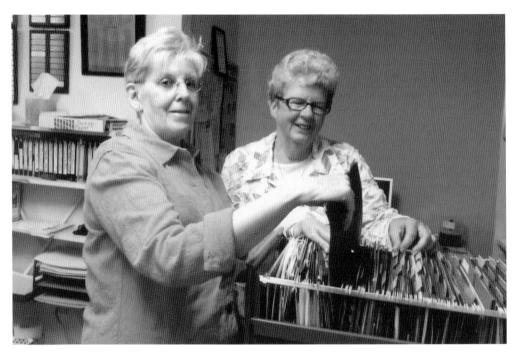

Preserving Tippecanoe History
Preserving the history of Tipp City is the main purpose of the Tippecanoe Historical Society. The museum, on the corner of Third and Walnut Streets, houses a variety of historical displays, photographs, obituary records, and information about the town and its residents. Shown here are Karen Kuziensky (left) and Susie Spitler, who are always working to increase and organize all that the museum has to offer. (Photograph by author.)

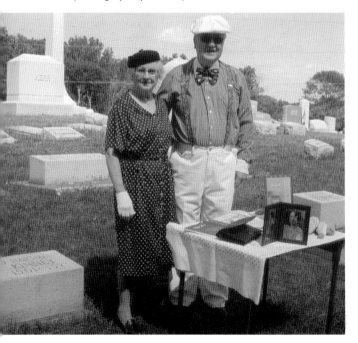

If Tombstones Could Talk
Another goal of the Tippecanoe Historical Society is to educate people about Tipp City's history. During the annual cemetery walk, If Tombstones Could Talk, actors dressed in costume portray people buried in Maple Hill Cemetery. Visitors can walk through the cemetery, stop at a grave, and listen to stories about people who lived in Tippecanoe and Tipp City. Here, Liz and Jerry Miller portray Grace and Hartman Kinney.

CHAPTER FIVE: IN SERVICE TO OTHERS

Caring for the Elderly
Sarah Feghtly was not born or raised in Tippecanoe, but she left her mark here. At age 52, she married John Seighman, who persuaded her to buy property and build a house at 300 West Main Street in Tippecanoe with her own money. Seighman was a scoundrel, and they divorced six years later. As a result of her experience, Feghtly worried about women being penniless in their later years. In her will, she left her estate to the General Synod of the Lutheran Church to establish a home for indigent widows and maiden ladies. In 1905, the Feghtly Home opened. The home closed for lack of funding in 1981, and its residents were relocated. Feghtly is buried in a family gravesite in Pennsylvania, but this monument was erected in Maple Hill Cemetery in her honor. (Photograph by author.)

Tipp City's EMS
Until the 1970s, Tipp City was thought to be too small for an emergency squad, but local doctors disagreed. Dr. E.R. Morlidge convinced the city council of the town's need for its own life-support vehicle. Volunteers had been using hearses from Frings & Bayliff Funeral Home, but with community support and the American Legion's solicitation of funds for an ambulance, the Tipp City Volunteer Emergency Squad was created in 1975.

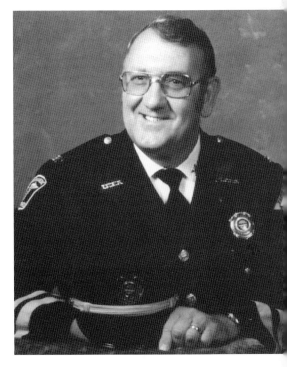

Emergency Squad Chief
Lowell Hampton was working for the Tipp City Police when he was asked to organize the Tipp City Emergency Services in 1974. He trained as a paramedic and served as the squad's chief from 1974 to 1990, improving the squad and its equipment over the years. He was said to be a person who devoted his life to serving others. He died in February 2013. (Courtesy of Carla Ungerecht, editor of *Tippecanoe Gazette*.)

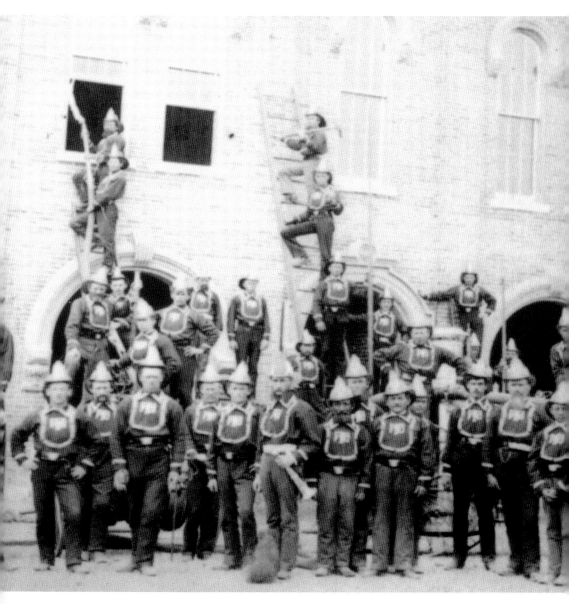

First Fire Chief

Charles Trupp was born in Saxony, Germany. He immigrated to the United States and settled in Tippecanoe in 1852. Trupp fought in the Civil War and afterward purchased a one-third interest in the sash and blind factory, Trupp, Weakley & Company, which became the largest manufacturer in Tippecanoe. He was active in civic affairs, serving on the town council, the township trustees, the school board, and the community band. He organized the Volunteer Fire Fighters in 1872, personally funded the construction of the fire station on Third and Main Streets, and was its first chief. The council required that "All members of the department be sober and industrious men and have an interest in the village." In this 1875 photograph of the Volunteer Fire Fighters, Trupp is most likely the man at center with the signaling trumpet.

Volunteer Fire Department
Tipp City was woefully short of proper equipment to protect the town until the 1950s when a group of volunteer firefighters decided to take action. The passage of two bond levies facilitated the purchase of equipment and reduced insurance rates to the same level as towns with full-time, paid fire departments. This 1960 photograph shows the Tipp City Fire Department in front of the original fire station at Third and Main Streets. Passing trains could delay fire equipment getting to the west side of town, but this problem was solved by building a new fire station on Main and Hyatt Streets.

CHAPTER FIVE: IN SERVICE TO OTHERS

Longtime Police Chief

Tom Davidson began his career in law enforcement in the US Army Military Police. After his discharge, he served with the Bowling Green police for 20 years while earning degrees in criminal justice and public administration and graduating from the FBI National Academy. In December 1990, he was appointed chief of police in Tipp City, serving for 22 years until his death in 2013. (Courtesy of Carla Ungerecht, editor of *Tippecanoe Gazette*.)

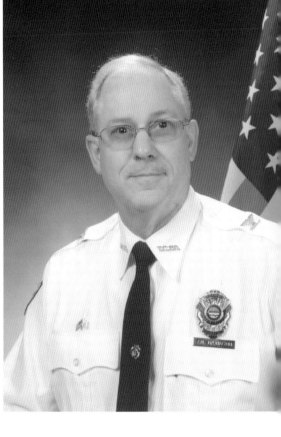

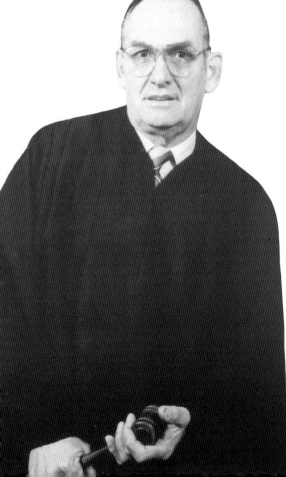

The Judge

William Kessler was the son of town librarian Catherine Kessler. He served as prosecutor for Tipp City, Miami County prosecutor, common pleas judge, and as the first municipal court judge in Miami County. Known for dispensing justice with a sense of humor, Kessler earned his law degree by hitchhiking back and forth to Ohio State. He loved to fish and bake homemade cookies called Kessler's Krispies. (Courtesy of Carla Ungerecht, editor of *Tippecanoe Gazette*.)

CHAPTER FIVE: IN SERVICE TO OTHERS

First Librarian
In 1923, the first public library in Tippecanoe opened its doors on the second floor of the City Building. As a certified librarian, Lulu Cottingham (left) was hired, with Anna Shaffer (not shown) as her assistant. They served together for over 20 years until Cottingham's death. The two of them worked together so well that "you couldn't tell the librarian from the assistant."

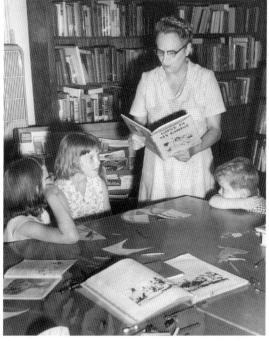

Small But Mighty Librarian
The next librarian was Catherine Kessler. She was a small woman, but mighty, and she demanded quiet. She could also instantly tell a patron where every book in the library was located. When the library outgrew its space on the second floor of the City Building, the books were slid out the window and down a chute to the sidewalk, into waiting arms, and carried next door to the present-day library.

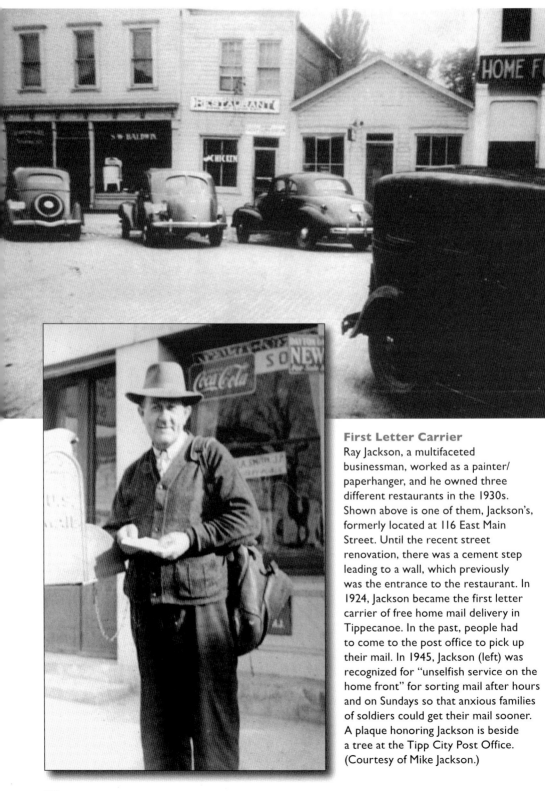

First Letter Carrier
Ray Jackson, a multifaceted businessman, worked as a painter/paperhanger, and he owned three different restaurants in the 1930s. Shown above is one of them, Jackson's, formerly located at 116 East Main Street. Until the recent street renovation, there was a cement step leading to a wall, which previously was the entrance to the restaurant. In 1924, Jackson became the first letter carrier of free home mail delivery in Tippecanoe. In the past, people had to come to the post office to pick up their mail. In 1945, Jackson (left) was recognized for "unselfish service on the home front" for sorting mail after hours and on Sundays so that anxious families of soldiers could get their mail sooner. A plaque honoring Jackson is beside a tree at the Tipp City Post Office. (Courtesy of Mike Jackson.)

CHAPTER FIVE: IN SERVICE TO OTHERS

Mail Carrier Today
Victor Cobb, a modern mail carrier, walks many miles six days a week delivering letters, packages, and magazines door-to-door in town, making friends as he goes. Cobb, a well-known face on his route, is representative of all the city and rural postal employees who serve the public on a daily basis. (Photograph by author.)

Delivering the *Tipp Herald*
Grant Johnson, known as "Handsome," walked many miles every week to deliver the *Tippecanoe Herald* in the 1920s. Delivering the paper and collecting the weekly subscription money is not done by paperboys anymore, but it was a familiar sight for many years, and Handsome was one of its well-known faces.

Caring for Final Resting Place
Robert Jackson, son of Ray Jackson, saw St. John's Catholic Cemetery on Evanston Road fall into disrepair for lack of a caretaker, so he volunteered to supervise its maintenance and care, and he performed the service for over 50 years. From 1944 to 1994, Jackson maintained the gravesites, supervised burials, and planted 625 walnut trees behind the cemetery. In 1995, Mayor Sue Cook presented Jackson with a plaque that recognized "citizens who have unselfishly contributed their time and talents to the betterment of the community." Jackson said of the honor, "I was never one to get awards. I don't know how to receive." He also found time to be an active member of the Tippecanoe Historical Society, serve as a precinct chairman, and was honored as Senior of the Month. He would like to be remembered as "someone who served the parish well." (Courtesy of Joyce Kister.)

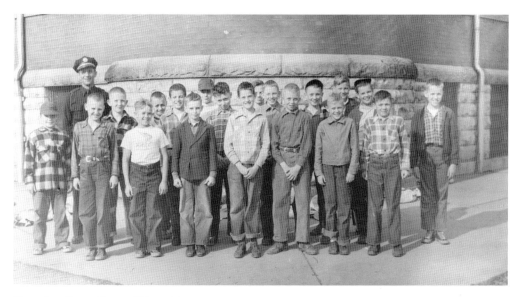

Keeping Boys Out of Trouble

In the 1940s, Tipp City patrolman Floyd "Sonny" Fair had an idea to help youngsters in his town stay out of trouble. He organized a schoolboy safety patrol, shown above in 1949. Fair is in the back left. Using a concept that was progressive for its time, the safety patrol "included boys from broken homes and boys from happy homes." By the end of the first year, there had not been a single traffic casualty during school hours. Fair thought that the boys needed still more activities, so he organized a baseball team, built Soap Box Derby cars, and, with the help of Mrs. Darrel Schulte and Mrs. Floyd Byrd, created the Safety Patrol Glee Club. The boys sang at numerous local functions and on WHIO-TV in December 1949 (below). Below, Fair is on the right with Schulte and Byrd at the piano. Their rendition of "Shortenin' Bread" was a fan favorite.

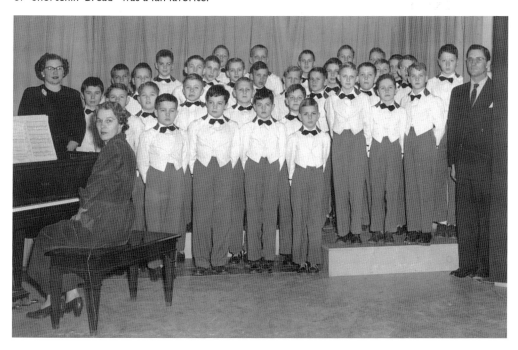

Policeman from New York (ABOVE AND OPPOSITE PAGE)
Ron Re, a transplanted New Yorker, settled in Tipp City over 40 years ago, bringing with him his wife, Sue Ann, his cowboy boots, and his New York accent. Re dreamed of being a cowboy all his life, so, as a New York City policeman, he joined the mounted police unit. His love of horses then brought him to a horse show in the Troy area and to the former gas station at Third and Main Streets in Tipp City, where he asked if the town had a police department. The police station was across the street, so Re asked Chief Jack Cheadle if he needed another officer. Tipp City had just become a 24-hour department, so Re was hired and spent the next 35 years in his "dream job." Getting used to life in a small town was not easy for this New York City transplant. Once, he pulled over a man for waving "hello" at him. He thought the guy was up to something, but when he found out the truth, Re thought, "People are a heckuva lot different than what I'm used to, so either they're gonna change or I am." He decided it would be easier if he did the changing. In addition to being a well-respected police officer and voted "most well-known person in town" by the local newspaper, Re donates his time to worthy causes and is active in many community organizations. He has been a member of the Tippecanoe Lodge of the Free Masons for over 30 years, serving as its Worshipful Master in 2009. The Masons are dedicated to giving back to the community, and Re says that they are a strong influence in his life, encouraging him to "formalize all the good he tries to do on a daily basis." His recent project is spearheading the construction and maintenance of Veterans Memorial on the corner of Hyatt and Main Streets. Re is not a veteran himself, but he has tremendous respect for all who have served. Re was voted Tipp City Citizen of the Year twice, in 1977 and again in 2006. He is the only person to be so honored. He believes that his greatest achievement will be if people say, "Hey, he was a good man in his life." Everyone who knows Re agrees that it is already true. (Both, courtesy of Ron Re.)

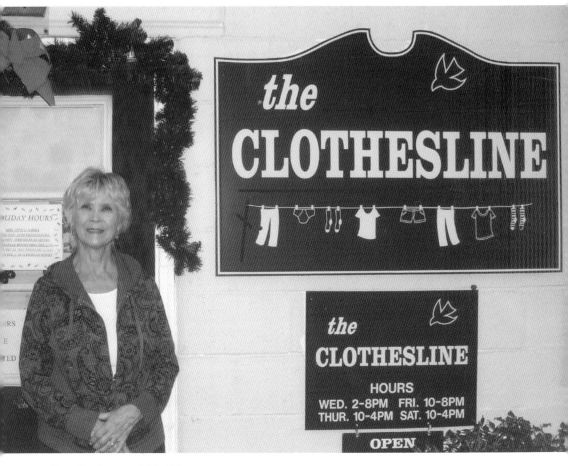

For the Love of Clothing

Since moving to Tipp in 1973, Peg Hadden has become an indispensable part of her adopted hometown. She arrived with her husband, Hugh, when he took a job with A.O. Smith Corporation, making Ohio the eighth state the family had lived in. One of Peg Hadden's greatest pleasures comes from collecting vintage clothing, which goes along with Hugh's hobby of collecting and selling vintage toys. When her attic became full of her clothing "treasures," Peg moved everything to the third floor of the 1917 high school, and from there she costumes all the school plays in Tipp City. With a dramatic flair of her own, she was also one of the founders, in 1975, of the local community theater group Tipp City Players. Hadden costumed as well as performed in many of the troupe's early shows. She also produced and costumed both of the Tippecanoe historical plays written by this author and sponsored by the Tippecanoe Historical Society in 2004 and 2007. Hadden again put her love of clothing to work by starting a nonprofit, secondhand clothing store called The Clothesline. It was first housed in the Roller Mill, then in a garage on County Road 25A, and now in its present location on North Second Street. Volunteers sort and price all donations and donate anything unsold to the World Relief Program. In 2012, profits of nearly $40,000 were given to 43 organizations that reach out to others, such as food pantries and abuse shelters. Along with her volunteer work, Hadden devoted 12 years to teaching third, fourth, and eighth grades. She taught for six years with this author who remembers those years as some of the best and most fun of her career. Hadden also brought Power of the Pen, a statewide competitive creative-writing program, to the Tipp City schools, coaching her young authors to award-winning status. Named as Tipp City Citizen of the Year in 2005, Peg Hadden is one of the many legendary faces of Tipp City today. (Courtesy of Peg Hadden.)

CHAPTER FIVE: IN SERVICE TO OTHERS

Local Cable Television

When cable television came to Tipp City in the 1980s, it opened the door for nonprofit programming within Monroe Township. It began with Ron Thuma and others organizing the Tipp-Monroe Cable Access Commission in 1982 and advertising for volunteers. Among those who answered the call were, shown below, Nonda Evans Harvey (left), Bill Cost (center), and Marilyn Fennell. In the early days, they carried bulky, hand-me-down video cameras to document events like school board meetings and the Mum Parade. There was also no way to edit the footage at the time. But the station has grown and modernized its equipment since then. The only thing that has not changed is the focus on local activities and information. KIT-TV (Keeping In Touch Television) is funded by the city council and the Monroe Township Trustees. Employees like Greta Clingan and Wendy Bauder keep it running. (Both photographs by author.)

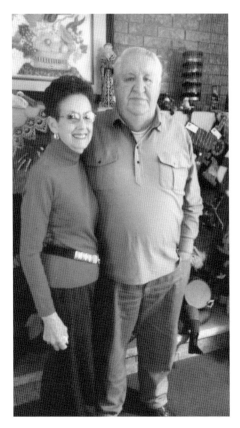

Serving the Community

Tipp Monroe Community Services was an entirely new concept when Mary Lou Wilson and others had a vision for a community-wide education organization. She and her husband, Howard "Jim" (shown here), worked many hours to bring it to life. It began with a group of people that included John Lorms, Otto Frings, and members of the Rotary who wanted more opportunities for the youth in Tipp City. They researched a similar program in Flint, Michigan, and secured step-down funding from the Mott Foundation, which provides grants to grassroots organizations for community education. Then it was time to bring together people from the schools, the Monroe township trustees, and the city council. Finding common ground was not easy, but Mary Lou Wilson served effectively as the liaison among the groups. The schools were designated to run the program, and the first directors were teachers, but there was a need for someone to work after regular hours, and Jim Wilson stepped up as assistant director. He was active in the implementation of many community-wide programs, beginning with sandlot baseball. The first day, he had 10 young ballplayers, and by the third day, he had 40. Still, Mary Lou's vision was to make it entirely community-run, so, after much conversation, the city and the township trustees each gave $16,000, with the schools providing the facilities on the condition that, after one year, a levy would be placed on the ballot. Mary Lou became the first director under this new design. Jim continued to work with the schools and was instrumental in starting the Top Scholars banquet to recognize scholars in the same way that athletes are honored. He worked with Terry Heater to enlarge the wrestling program. Jim said, "All it took was somebody from the outside to help and encourage" by getting mats and equipment. Jim also worked behind the scenes on such projects as securing donations toward scholarships, filling packages for troops in Afghanistan, and even making calls for Santa Claus. He says, "It's amazing what people will do if you just ask." In Ohio, many similar community-based programs have disbanded, but both Wilsons agree when Mary Lou says, "I feel so good that I could be part of that foundation . . . and years later it is still going strong." (Photograph by author.)

Making a Difference

Gordon Honeyman chooses to work for his beloved Tipp City in understated ways. He is involved with the Tipp City Educational Endowment Board, the Tipp City Foundation, the Tipp City Players, the historical society, and was an organizer of the revitalization of the school alumni association in the early 1990s. He has also served on the original restoration board and worked with the city on tree planting and beautification. Voted Tipp City Citizen of the Year in 2011, Honeyman is described as "the essence of the small town hero; the quiet everyman who makes a difference every day." Honeyman said that the honor was "not so much a personal triumph as much as a validation of my lifelong love affair with my home town. This little town touches people." (Courtesy of Gordon Honeyman.)

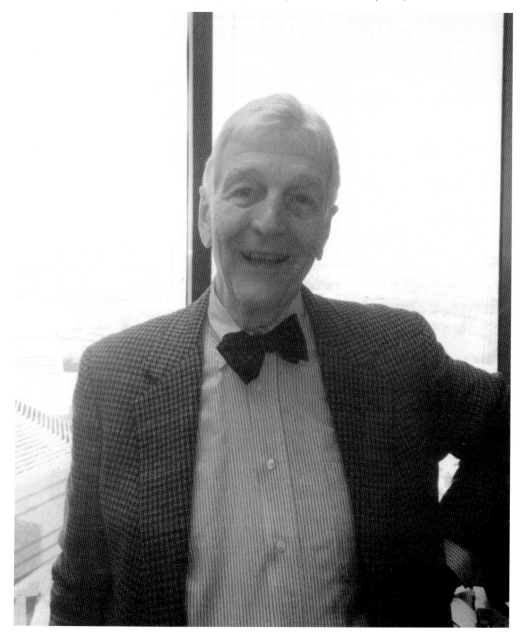

Leader of the Band

As a child, Gail Horner Ahmed twirled her baton on *The Ed Sullivan Show*. She was teaching twirling in 1977 when she was hired as Tipp City's first female high school band director. In 1980, she was approached to form a community band. The first practice saw seven players in attendance. The band now boasts over 40 players. Its first performance was at Liberty Commons, followed by an evening concert at Second and Main Streets. The band typically performs over 10 times a year at venues around the Dayton area. On one hot summer day, the band played at the opening of Hyatt Medical Center. The blacktop in the parking lot had not cured, and as the musicians played, their chairs sank into the asphalt! (Above, photograph by author; below, courtesy of Carla Ungerecht, editor of *Tippecanoe Gazette*.)

CHAPTER FIVE: IN SERVICE TO OTHERS

Flying with VIPs

In 2006, hometown man Sgt. Chris Seagraves was part of a security team protecting *Air Force One* and its passengers. Seagraves flew with such notables as Pres. George W. Bush, Colin Powell, and Al Gore. In the above photograph, Seagraves is on the right as President Bush boards the plane. In the below photograph, Seagraves poses with Hillary Clinton on another flight. While he had the opportunity to spend time with many distinguished people, his duty to provide security always took priority. Seagraves remarked that if anyone was impolite, all Seagraves had to say to that passenger was, "Remember where you are," and the problem was resolved. One perk was that when *Air Force One* was at the Dayton airport for President Bush's visit to Troy, Seagraves treated his family to a tour of the famous aircraft. (Both, courtesy of Brenda Seagraves Lutz.)

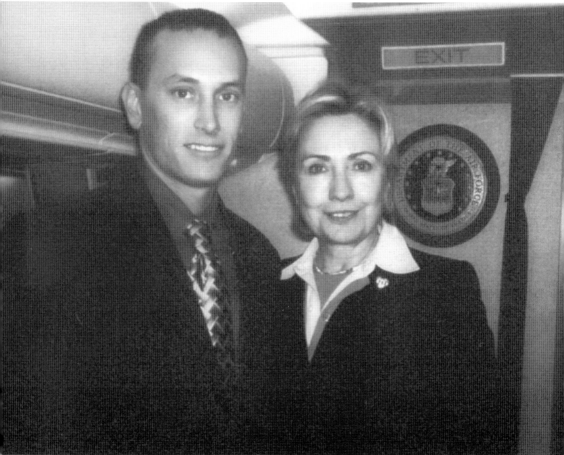

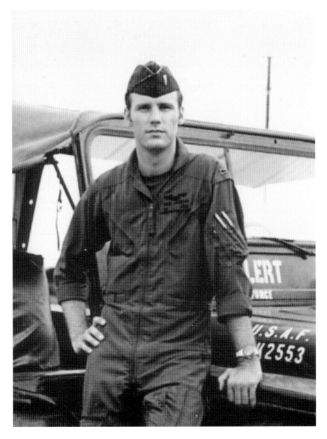

Welcoming Veterans Home (ABOVE AND OPPOSITE PAGE)
Lt. Col. Mike "Scoop" Jackson, a decorated combat pilot and career Air Force officer, is shown in the above photograph during his tour of duty in the Vietnam War. He wrote about his time in-country in a book he coauthored with Tara Dixon-Engel, *Naked in Da Nang*. He quips that "the only stories I tell about the war are the funny ones." The book is not as much about the conflict as "the absurdities in a combat zone." He also coauthored five books for children in a series called Embracing Freedom. From personal experience, Jackson knew that veterans of the Vietnam War had returned home to jeers and derision, not to the cheers and parades they deserved. His goal was to rectify that with Operation Welcome Home. The initial idea has grown from one national parade and celebration in Las Vegas in 2005, to a parade in California in 2006 and another in Indiana in 2008. Today, Operation Welcome Home honors veterans from all the nation's wars. In the bottom photograph on the opposite page, Jackson and Dixon-Engel are shown leading the Las Vegas parade. Overflowing crowds cheered on the veterans, and the number of marchers in the parade grew as initially hesitant vets along the route were beckoned into the throng. After retiring from the military, Jackson was the executive director of the National Aviation Hall of Fame for 13 years, taking it from near bankruptcy to a multimillion-dollar facility. He left that job to be the national chairman of Operation Welcome Home. Since then, Jackson has used his frequent speaking engagements and television interviews to help others organize celebration parades. He does not know exactly how many places have held Welcome Home parades, but, aware that many have, he says, "It's kind of cool!" He was voted Citizen of the Year in Tipp City in 2004 and has received numerous humanitarian and community-service awards for his work with veterans. Jackson's oldest daughter, Lori, also served in the Air Force. In the above photograph on the opposite page, they are shown pointing to their bricks at the Tipp City Veterans Memorial Park. (All, courtesy of Mike Jackson.)

CHAPTER FIVE: IN SERVICE TO OTHERS

Husband and Wife Mayors
In the mid-1960s, as a result of population growth, Tipp City changed from a village with a strong mayoral government into a city with a council and city manager. Dave Cook (left) worked with the Jaycees to develop the necessary changes to the city charter. He then ran for city council, serving from 1974 to 1986. Several years later, his wife, Sue (right), unhappy with decisions of the council, campaigned, won a seat, and at her first meeting was elected mayor. Each Cook served as mayor for six years. As mayors, they performed nearly 200 marriages and saw the creation of the Downtown Restoration Board, emergency services, Tipp Monroe Community Services, neighborhood parks, and the Robinson branch of the YMCA. The Cooks also devised a disaster plan after the 1978 blizzard. Dave was voted Outstanding Young Man in 1969, and Sue was named Citizen of the Year in 2001. (Courtesy of Dave Cook.)

CHAPTER FIVE: IN SERVICE TO OTHERS

Family in Service
For the Wahl family—Bob, Jackie, and their daughter Katie—giving of their time and talent to make a difference in Tipp City is a tradition. Katie said, "Growing up, the importance or expectation of philanthropy was never discussed. Instead, community involvement and support was simply the norm." In recognition of their contributions, Bob and Jackie Wahl were named Philanthropists of the Year for 2013. In 1995, Jackie was recognized as Citizen of the Year. The organizations and events that the family has supported are too numerous to name here, but just about every aspect of Tipp City life has been touched by them. A special memory for Bob was chairing the Mum Festival Parade for five years. The huge task involved organizing the floats and bands and starting every marching group in the right order—making sure, for example, that the music of the band did not drown out the Girl Scout troop ahead of it. Bob also built many of the booths and games during the first year of the annual Broadway School Fun Fair Fund Raiser. Jackie (left) says that she prefers "to be the worker bee, not the queen," and that she is best at things that take her out of her comfort zone. She is especially proud of working on the income-tax levy campaign to maintain and improve Tipp City parks. Sitting on the Tipp Foundation Board, which provides grants to area organizations, gives her satisfaction because of the positive impact it has on the community. Katie (right), an attorney, says "Volunteering is part of my job as a member of the community. If something needs to be done, then do it." She enjoys her work on the library board because "access to information is the great equalizer." She also sits on the board of trustees for the Dayton Foundation for the Arts. In 2012, she spoke at the Top Scholars Banquet at Tippecanoe High School and taught a semester of economics, something she would like to do again. Annie, the eldest daughter, now lives in Oxford, Ohio, but she continues the family tradition of service there. The Wahls love this "little town of Tipp City, Ohio," and Tipp City has been enriched by that love. Bob died in 2013 after a long illness and will be missed by so many. (Photograph by author.)

Ministering to the Community

When Rev. James "Jim" Hartland arrived in Tipp City in the 1970s to pastor the Tipp City United Methodist Church, he began a community-wide ministry. At Thanksgiving, he organized the first multichurch, ecumenical service with five downtown churches. The following April, the same churches came together for Easter services. During the blizzard of 1978, Hartland walked through the storm to open the church for hundreds of motorists stranded by the closing of I-75. He welcomed everyone and even got the children to put on a show; instead of being marooned, they had one big party! A stranded soldier became technically AWOL, and Hartland wrote a note to his commanding officer excusing him. Hartland was known for greeting everyone, regardless of age, with "How are you kids today?" In the below photograph, he is shown baptizing his great-granddaughter Grace. (Both, courtesy of Marilee Lake.)

CHAPTER FIVE: IN SERVICE TO OTHERS

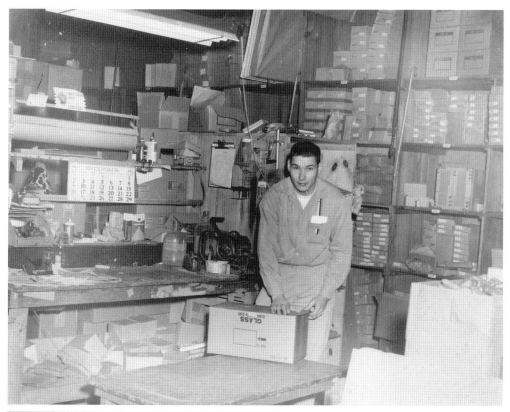

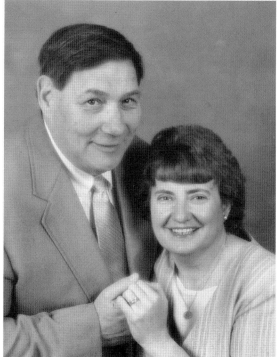

Seeing them Everywhere
Gordon and Joanna Pittenger can be seen in many places around town. Gordon worked at Tipp Novelty for 43 years (above) and was manager of the novelties department for 30 of those years. He coached Little League baseball, performed the "cold job" of selling Christmas trees for the Jaycees, and still does filming for KIT-TV. He is vice president of the Tippecanoe Historical Society, president of the Tippecanoe Alumni Association, and works during the Optimist Club's live television auction to raise money for youth activities. Gordon also enjoys creating posters for these events. Joanna, shown below with Gordon, volunteers on the Tipp Emergency Squad and is chief of the Indian Lake Emergency Squad. She serves on the Tree Board, the Cable Access Commission, Community Minded Women, and two historical societies, one in Tipp City and one in Bradford, Ohio. (Both, courtesy of Gordon Pittenger.)

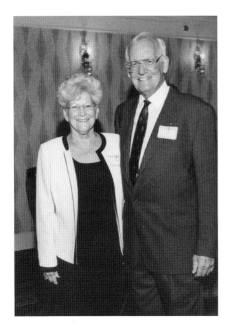
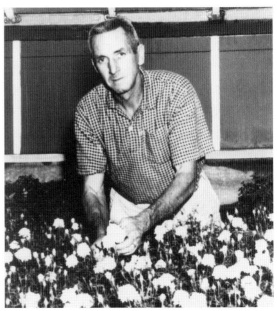

Brothers around Town

The Kyle family name has been prominent in Tippecanoe and Tipp City for over a century. Harry Kyle took over as treasurer of Spring Hill Nursery when Peter Bohlender retired in 1909. Harry, shown on the right with his bride, Lyvrgia, was the father of Betty, Howard, Thomas Sr., and Mary. Thomas Sr. (above right) served as president of Spring Hill from 1929 to 1974, on the city council, as school board president, Rotary president, Mum Parade Marshal, president of several Nurseryman Associations, and was Citizen of the Year. He was also the first inductee in of the Mailorder Nurserymen Hall of Fame. With his first wife, Hilda, he had three children, Karolyn, James Howard, and Thomas Jr. Following the example of their father, Thomas Jr. and James "Jim" were active in the community and in the nursery business. Both men served as Rotary president, were Citizens of the Year, and were elected school board president. Tom Jr. was one of the founders of the Mum Parade, and Jim was the first living inductee in the Mailorder Nurserymen Hall of Fame. Jim's daughter, Kate Kyle Johnsen, serves on the Tipp City Board of Education, continuing the family tradition. Shown above left are Jim Kyle and his wife, June. (All, courtesy of Kate Johnsen.)

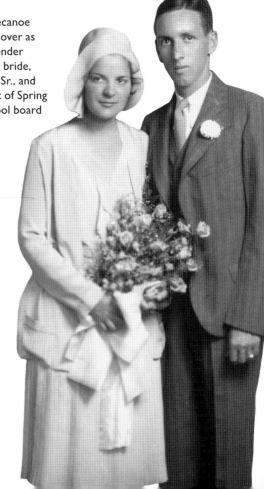

CHAPTER SIX

Those We Remember

Some people are not legendary in the typical notions of fame and fortune. Their names might be known to only a few, but the ways that they touched the lives of those around them will never be forgotten. These are people who offered of themselves, whether in a big way or with just a kind word and ready smile.

Kenny Trost is fondly remembered as the epitome of a legendary character with his hobby of "rescuing" discarded things, especially old paintings. The trunk of his car was always packed with his findings. When the trunk was opened, there was always the possibility that things might pop out! Grace Kinney will always be remembered for her collection of historical information about Tippecanoe and Tipp City, but perhaps even more so by the young paperboys she and her husband, Hartman, mentored.

Dr. Duff Hartman and his family, Nellie Herr Smith, and the Mast Girls, Danza and Erma, remain in people's hearts because of their outgoing personalities and their willingness to give their hand in friendship. The photographer Thomas Crook took stunning photographs of Tippecanoe and its surrounding landscape. The words "Crook's Studio" will forever be emblazoned on the back of the originals. His classic photographs immortalize the places and people of yesteryear for generations to come. Ned Sprecher fought bravely in World War II and received medals for his courage, but what mattered more to him was how he lived his life. For that, he is a real hero to his friends and family in Tipp City.

Most people will never save someone from a burning building or find a cure for cancer, but their time on this earth will still be honored by those who knew them. They will be remembered by those who enjoyed their company and were sad when they passed out of this life.

There are many such people in Tippecanoe and Tipp City. Here are only a few.

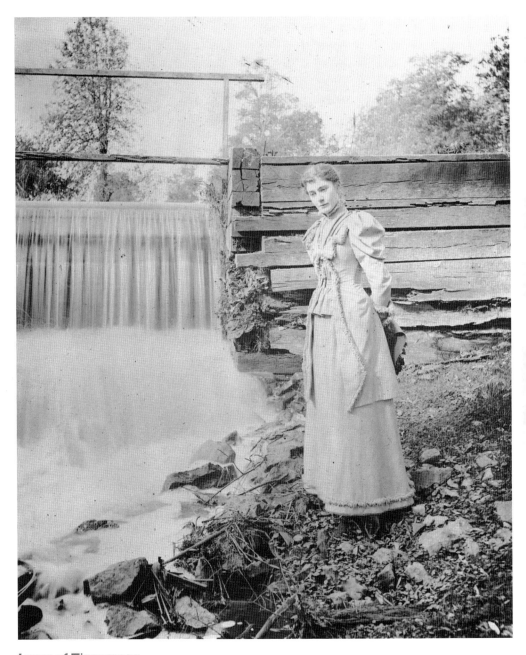

Lover of Tippecanoe
As a young woman, Nellie Herr liked having her photograph taken in places that featured her beloved Tippecanoe's landscape. She is seen here beside Lock No. 15 on the Miami and Erie Canal. In 1899, she married John "Blackie" Smith, owner of the Blue Bird Tearoom. With the Women's Civic Club, Nellie Smith championed a plan to put the first public library on the second floor of City Hall. After a fundraising community lawn party and the receipt of matching funds from other sources, the library opened in 1923. Smith, still on the library board 40 years later, donated land for the present-day library on Main Street. On her 90th birthday, the Garden Club threw her a grand party, and when she died at age 97 she was Tippecanoe's oldest resident.

CHAPTER SIX: THOSE WE REMEMBER

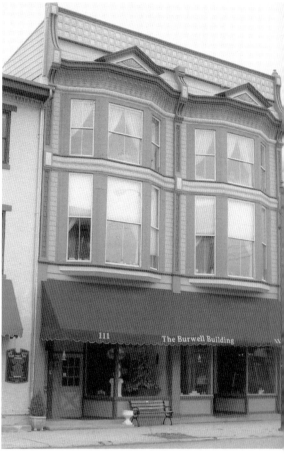

Photographer of Tipp City

The left photograph is a self-portrait of Ralph Burwell. As an only child, he was not allowed to play with other children for fear that he would get hurt or dirty. He grew up to become a lonely man, but a talented photographer, taking timeless photographs of Tipp City. In 1880, his father, John, built the Burwell Building (right) on East Main Street. The second and third stories have large bay windows and skylights, perfect for Ralph's photography studio. Burwell, tall and thin, wore wire glasses and always sported black suits and carried a walking stick. He kept to himself and often lived without heat or indoor plumbing—he was leery of that "newfangled" toilet stool. He liked to design Christmas cards, which he sent to the few people he knew.

Gravesite Historian

Nellie Freet Hartley had history in her blood. Her great-great-great-grandfather, William Dorby, spied for George Washington during the Revolutionary War. She was born in 1911 in Tippecanoe, married Harley Hartley in 1931, and traveled with his railroad job until returning to Tipp City in 1965. Harley died in 1968, and her only son, Jack, was killed in a car accident in 1975. To keep busy, she joined several historical organizations, and in 1995, she began keeping records of all the tombstones in Monroe and Bethel Townships. At the Kepper Cemetery off State Route 202, Hartley prepared a large display board (below) that lists all the graves of the early settlers buried there. Her childhood memories of Tippecanoe were recorded on audiotape by the historical society shortly before her death in 2005 and are preserved at the museum. (Below photograph by author.)

Stunt Flyer and Inventor
Charles Norman "Weez" Wenzlau was the youngest of three sons raised by his widowed mother, Eugenia, at 115 West Main Street. Wenzlau is shown here with his wife, Alice, in 1922. During World War I, Weez Wenzlau enlisted in the Army, trained as a pilot, and did some barnstorming and stunt flying after the war. For nearly 60 years, starting in 1920, he owned the gas station on the corner of Third and Main Streets. He became the postmaster in 1936 and served as a volunteer firefighter for many years. One of his hobbies was building things in his garage, and he once invented a unique bicycle. He also loved trains, and whenever a whistle sounded, he ran up to the tracks to watch the train go by. He jokingly said that his greatest achievement was, "I have all my own teeth."

Orphan Train Passenger
From 1853 through the 1920s, trains came west with special passengers—orphans. The Children's Aid Society, a social agency in New York City, brought parentless children to homes in the country. In Tippecanoe, Frank Martin was adopted by a family that mistreated him. Later, he came to the Hill family and became Frank Martin Hill. His nickname was "Speed," and he graduated from Tippecanoe High School in 1915. His wife, Eva Spitzer Hill, sold Avon products for over 50 years to support her husband, who, after fighting in World War I, suffered from "shell shock." He was hospitalized for a time and was unable to work steadily. Eva was known for walking "a mile a minute" while selling cosmetics to her customers. According to the 1940 census, she made $400. She died in 1999 at age 100.

CHAPTER SIX: THOSE WE REMEMBER

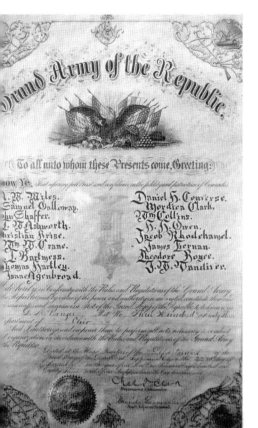

Civil War Hero

Daniel Rouzer prospected during the Gold Rush and then headed to Tippecanoe in 1856 to build a distillery. During the Civil War, his company, Rouzer's Raiders, figured prominently in many victories. He ran a grain elevator, a grocery store, was on the city council, was a Monroe Township trustee, and served on the board of education. The charter for the D.M. Rouzer Post of the Grand Army of the Republic (left) hangs in the American Legion hall on Third Street. Several of the signatories are mentioned in this book. Rouzer's house was moved to Miles Avenue (below) from Main and Fourth Streets to make room for the new post office. It is thought that Rouzer buried his horse in the backyard and requested that nothing be built over it. Rouzer's funeral in 1881 was "the largest ever seen in Tippecanoe." (Both, courtesy of David Cook.)

101

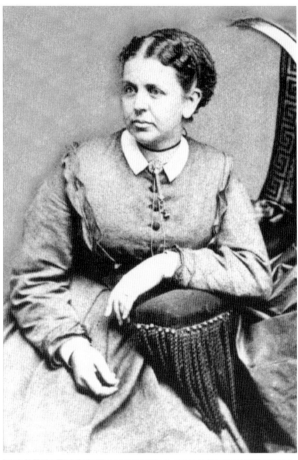

Tippecanoe Socialite
Martha "Mattie" Bennett Crane, wife of Weakley Crane, was a Tippecanoe socialite in Tippecanoe in the early 1900s. She was known for her parties, held in the third-story ballroom of her house on West Main Street (below). When the house was moved to that location, the third story was added to make it the tallest on the street. She was widowed and had no children, and in her later years, she was often seen sitting alone in the front window. She always dressed in black and wore the broach seen in the above photograph. She died in 1968, and the house, known as the Mattie Crane House, stood empty until it was renovated by several owners. Rumor has it that her ghost still haunts the house. (Above, courtesy of Gene Maddux.)

CHAPTER SIX: THOSE WE REMEMBER

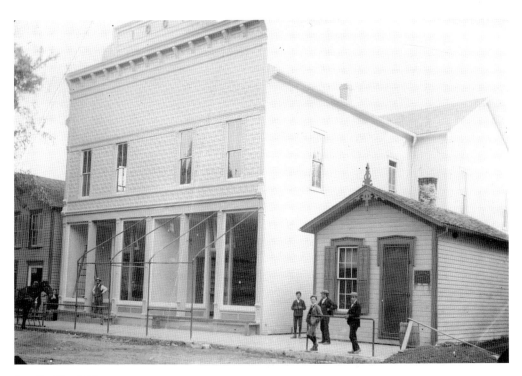

Dr. Duff's Office
Years ago, it was typical for doctors to set up small offices. The one shown above, belonging to Dr. Samuel "Duff" Hartman, was on the south side of Main Street beside present-day Benkins Antiques. Duff studied medicine and practiced with his father, Dr. Abraham Hartman. Samuel (below) was the youngest man in Miami County to enlist in the Union army, serving as a physician. For 25 years, he was also surgeon for the railroad. Dr. Duff, as he was called, was very proud of the car that helped him make house calls. It was said of him that he "always had bits of candy in his pocket for the children. . . . He would pat their heads and ask, 'How are you, daughter or son?' He was loved by everyone." Hartman died after a surgical procedure in 1923.

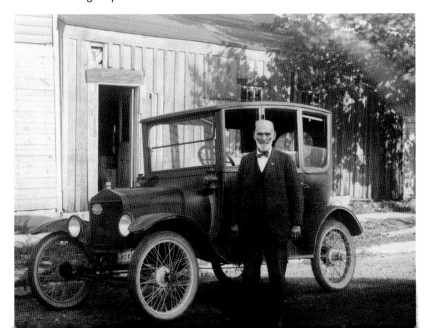

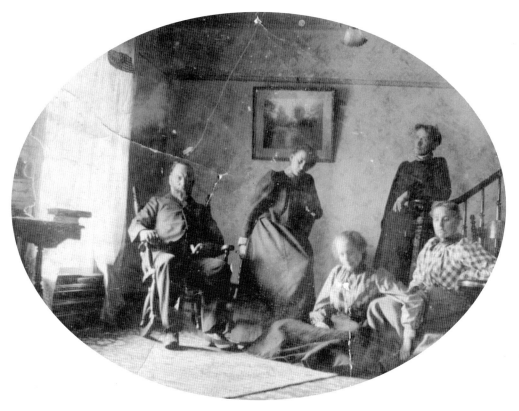

Hartmans at Home

This tintype photograph shows the Hartman family. They are, from left to right, Dr. Samuel "Duff"; daughter Carrie; wife, Laura née Byrkett; and daughters Ethel and Mary. All of them were active in the community. Carrie and Ethel sang in the church choir, and Mary played the organ. The sisters remained close, even living together in their later years.

Hartman Girls

The Hartman girls all married, but Carrie was the only one to have children, a son, Hartman Kinney. Ethel married Ed DeLangton, and Mary wed Harry Favorite. Carrie married twice, first to John Kinney (Hartman's father) and later to Clifford Mann. Pictured from left to right are Harry Favorite, Carrie Hartman Kinney Mann, Clifford Mann, Ethel Hartman DeLangton, an unidentified woman, and Mary Hartman Favorite.

Tippecanoe Historian

No collection of the stories of Tippecanoe or Tipp City is complete without including Grace Line Kinney. She was raised in Tyler, Texas, in a rambling hotel owned by her parents near the railroad tracks. She is shown here at center with two of her five siblings, Velma (left) and Beatrice. She met and married Hartman Kinney, and in 1932, she and her new husband came back to his hometown of Tippecanoe. To keep herself busy, Grace began recording as much history about her adopted hometown as possible. Her research was meticulous, and she and Hartman made almost daily trips to the county courthouse to check facts. She also wrote numerous letters, in her nearly illegible handwriting, to anyone who might have answers to her history and genealogy questions, and she saved most of that correspondence in her files. She was a frequent speaker at community clubs and organizations, and every child who studied local history made a trip to her house as part of their research. She and Hartman loved to sit on their porch on Second Street and tell their stories to anyone who would listen, and many did every night. Hartman's family roots went back almost to the founding of Tipp, so he had many "juicy" stories to tell. Grace recalled that their home had originally been a boardinghouse, The Barracks. Portions of the house were taken off and moved to nearby lots, creating three new homes. Hartman was the only son and nephew in the family, and he was doted on by his aunts Ethel and Mary and his mother, Carrie. The sisters were sole heirs of their father, Dr. Samuel "Duff" Hartman, who left them a vast amount of furniture, antiques, and memorabilia. Soon, the Hartmans' house became packed with these and other heirlooms that people in town thought Grace should have. She could not bear to part with any of it. She collected history of all kinds!

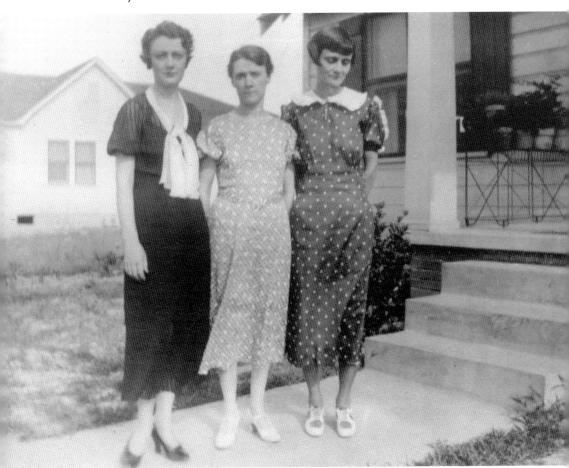

LEGENDARY LOCALS

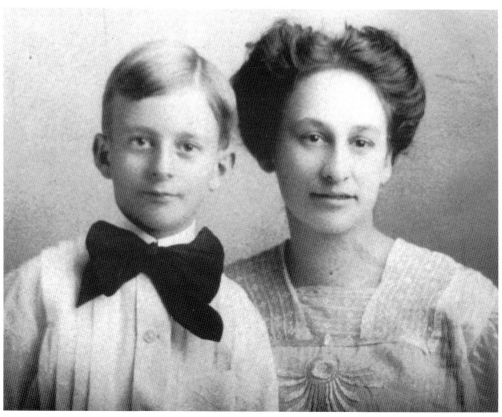

Hometown Man

John Hartman Kinney, shown above at about age 10 with his mother, Carrie Hartman Kinney, was born in Tippecanoe in 1900. Hartman met Grace while traveling on business in Texas and brought her home to Tippecanoe at the start of the Depression when he lost his job. He later joined his uncle, Harry Favorite, in the insurance business. One of the Kinneys' part-time jobs was distributing the Dayton newspaper. At that time, they lived on West Dow Street, and the local paperboys came there to pick up their papers. Hartman is shown on the left with his dog, Judy. Saturday was collection day, and Grace always made the boys do the math to figure out what they were owed. She demanded good manners toward all their customers, and these boys became the "sons" that Grace and Hartman never had. Hartman is shown at left with his dog Judy.

Doc and Little Doc

Edmund Girard Puterbaugh was born in 1900. His father, Charles, taught school until he inherited enough money to go to medical school, and Edmund followed that path, teaching in one-room schools until he attended medical school, graduating in 1929. He went into family practice with his father in Tippecanoe in the Detrick house west of Zion Lutheran Church. Puterbaugh was called "E.G.," or simply "Doc," and his daughter, Alice, was "Little Doc." He was a Civil War buff, and he scribbled comments in the margins of every book and newspaper he read. Doc once said, "I started working in the Darke County tobacco fields . . . and lived long enough to see the invention of the airplane and to watch men walk on the moon. It's been a full life." He died in 1977. (Courtesy of Gene Maddux.)

World War II Hero (RIGHT AND OPPOSITE PAGE)
During World War II, Kenneth "Ned" Sprecher was a member of the 101st Airborne (right). He fought during the early days of the invasion of Europe, earning a Distinguished Service Cross at the battle for Carentan, France. The top photograph on the opposite page shows Sprecher after that battle. In receiving that award, it was said, "While his company was pinned down by intense enemy machine gun fire, and Sprecher's company commander was knocked unconscious . . . Sprecher reorganized the company and personally led a bayonet charge upon the enemy thereby gaining the objective." His name is mentioned in a book about the invasion of Europe, although it is spelled wrong, and his experiences were detailed in a History Channel special. In 2003, Sprecher posthumously received the Ohio Medal of Valor and was inducted into the Ohio Veterans Hall of Fame, which is not a military organization, but one that recognizes postmilitary service to the community. Sprecher preferred to be remembered for his life in Tipp City. After the war, he went into the dry-cleaning business with his brother-in-law, Wilmer Leiss. Just one small part of Sprecher's work within the community was that he cleaned all the school flags and band uniforms free of charge. Sprecher was a three-time commander of the Frank Robinson American Legion, a member of the chamber of commerce, the Kiwanis, the Tipp City Color Guard for 30 years, and a cofounder of the Veterans of Foreign War Post No. 4615. In the bottom photograph on the opposite page, Sprecher (second row, second from right) is shown with the Tipp City baseball team. He said, "I like a small town, and my job [as vice president of Leiss Laundry and Dry Cleaning] is very interesting." His wife, Patti, said, "He was a gentle person. Everybody liked him." His grandson Michael Ellis recalls, "When I was growing up my grandfather was always a positive role model. . . . I spent a lot of time with my grandparents, and they were a positive influence on the community." At Sprecher's death, Judge William Kessler said, "I don't know if you ever saw Ned's legs. [Sprecher had been hit with shrapnel.] If you had then you would realize how significant his accomplishments are. . . . Ned never complained, but went on about life and helping the community as if nothing was wrong with him. . . . Those who knew him sadly miss him." (All, courtesy of Patti Sprecher.)

CHAPTER SIX: THOSE WE REMEMBER

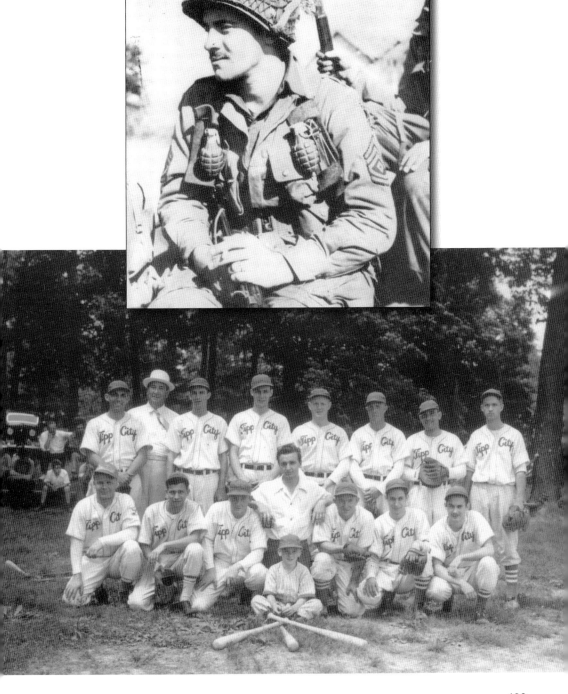

The Collector

Franklin Kenneth Trost, known as Kenny, was born in 1905 and is remembered as one of the true "characters" of Tipp City. He was a collector of what other people discarded. He regarded the items as treasures, and he brought home so many things from auctions, trash cans, and estate sales that, after his death, it took a year to sort through everything. One thing he particularly searched for was old paintings, "rescuing" hundreds over the years. He did not care about the quality of the work, but he could not stand to see art hidden away. Many paintings graced his own walls, but he also took quite a few to other people's homes, thinking they would enjoy a certain one. He then hung it on their wall, with or without their permission, and left satisfied that he had done a good deed. Trost was also one of the early ham operators in the area, licensed around 1919 with the call letters W8BAD. He is shown here in the small shack that he built for his radio equipment behind his family's house. He painted the building red with white trim. When he and his wife, Catherine, called "Toots," built a new house on Horton Avenue, he moved that little shack there, and it can still be seen from the road. Toots never had a complete set of dishes. Trost brought home odd china pieces, and they became the family's eclectic place settings. He only owned one new car in his life because he always went to the junkyard of his good friend, Rol Vocke, picked out a car, and drove it until it fell apart. Trost graduated from Tippecanoe High School in 1923 and is credited with designing the logo for the first yearbook, which was the word "canoe" in the shape of a canoe. Kenny played the flute in the school orchestra, and his high school sweetheart, Toots, played the piano. For many years, Trost worked for Tipp Citizens Bank, where he kept a list of all the "funny" sounding names of customers. He also read just about anything he could get his hands on, and he once said that he could read anything except Chinese. "I could never get the hang of that." Not an especially religious man, he said, in keeping with his reputation as a character, "I'd probably be Jewish. I like their food." (Courtesy of Jane Trost Powell.)

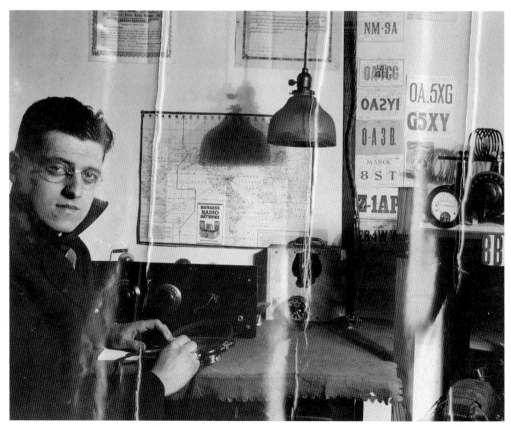

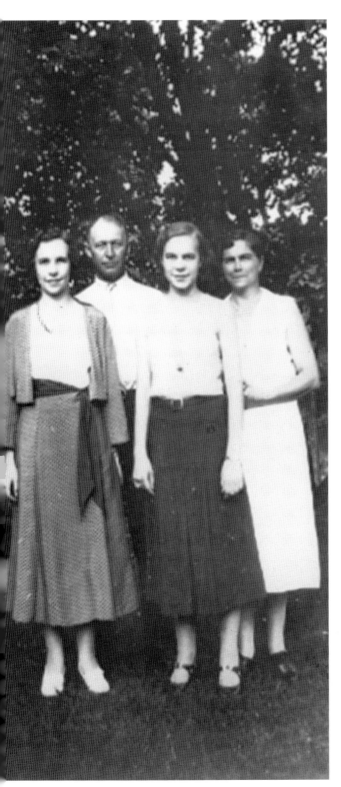

Mast Girls

In the left photograph, Henry and Minnie Mast (rear) pose with daughters Danza (left) and Erma, who were referred to as "The Mast Girls," even into their older years. The girls were rarely called by their given names; Danza was "Betty," and Erma was "Jim." The sisters lived together and never married, but instead of being "old maids," they were known for their friendly, outgoing personalities. The Mast Girls led an active social life with many friends and were admired for their elegant fashion style. They traded in their car every two years. People, knowing that they took excellent care of their vehicles, often requested the "Mast Girls' car" when looking for a used one. After moving into assisted living, two rooms were remodeled so that Danza and Erma could live together. They were popular residents for the rest of their lives. In the above photograph, Danza is at left, and Erma is at right. (Both, courtesy of Susie Spitler.)

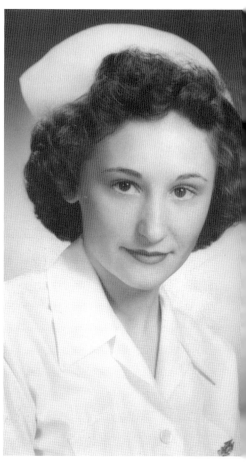

Colorful Couple (ABOVE AND OPPOSITE PAGE)
Alva and Jeanne Harris Parsons both called Tipp City home for all their lives, and they loved living in a small town. Jeanne said, "You are not a number but a name in Tipp City. You know your grocer, your mailman, and your barber," and just about everyone knew the outgoing Parsons. Alva (left) and Jeanne (right) met after World War II at Dumick's, a soda shop on the northwest corner of Second and Main Streets. Dumick's was known for inventing the Red Devil sandwich, a version of a Sloppy Joe that is still served in the schools today. The couple married in 1950 (opposite page) and had two sons, Tom and John. For two years after their marriage, Jeanne worked as a nurse and office manager for Dr. Maynard Kiser. She said that others may have found Doc Kiser gruff, but she enjoyed working for him. In 1960, Alva started the Parsons Insurance and Realty Office, and the couple worked together in the business until 1994 when it was sold to Stan and Jack Evans of Favorite Insurance. The Parsons were familiar faces at just about every community event in Tipp City. Jeanne said of her hometown, "I think Tipp is one of the most volunteering towns in the country!" Jeanne served with the Jaycettes, the Women's Civic Club, the alumni association, the historical society, and many more organizations. Alva had just as many associations to his name. Jeanne was one of the founders of the Tipp City Players in 1975, and both she and Alva performed on stage and worked behind the scenes for many years. Jeanne loved to decorate for Christmas and once hung three gold-painted garden hoes on the front of the house: Hoe, hoe, hoe! Alva died in 2005, just shy of their 55th wedding anniversary, but Jeanne's enthusiasm was still seen around town. She founded a chapter of the Red Hat Society, which included her mother. Jeanne served as "Queen Mother" and chief organizer until 2009. Jeanne Parsons died at age 81 in 2011. (All, courtesy of Phyllis Parsons Schindler.)

CHAPTER SIX: THOSE WE REMEMBER

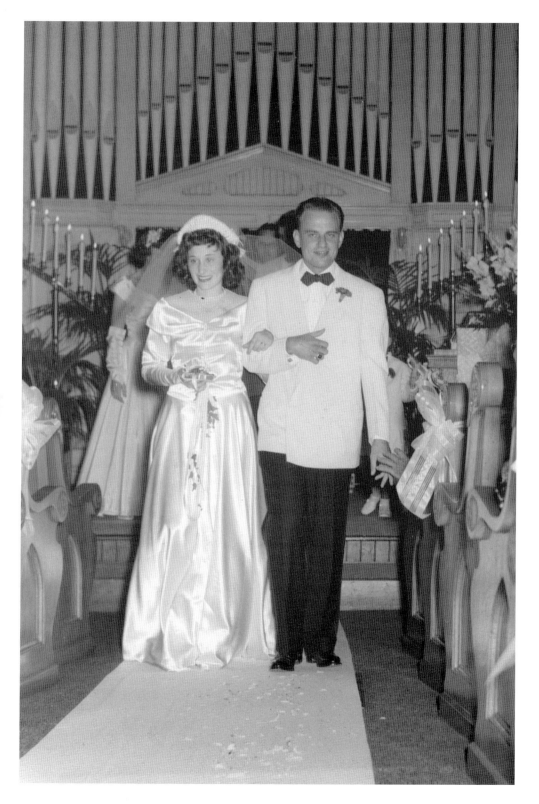

Telling Tippecanoe's Story

The performances of these cast members during two historical plays written by this author brought about a revival of interest in Tipp City's history. *Tippecanoe Our Story* (above), which told about the founding and early history of the town, was presented in 2004. *Tippecanoe Our Lives* (below), recreating the lives and lifestyle of people from the past, debuted in 2007. These amateur actors, ranging in age from 10 to 88, shared their love for Tipp City with each other and with audiences. They portrayed the stories while historical photographs were projected on a screen behind them. Later, the plays were divided into shorter segments and shared with community groups. Senior citizens enjoyed the memories, and schoolchildren saw their town's history come to life for perhaps the first time. (Both, courtesy of Fred Stiver.)

CHAPTER SEVEN

The Robert Evans Legacy

Many families came to southwest Ohio looking for a better way of life, and when they found it in Tippecanoe, generation after generation stayed. Although many names that were familiar in the 1800s are no longer on the town's rolls, the memories of these parents and grandparents still endure with the generations that came after them.

Although not forgotten, some aspects of life in Tippecanoe have disappeared. No longer will residents see the bustling activity of the Miami and Erie Canal. Lost are the locations of the eight distilleries that once stood on First Street. Many places that were once family homes are gone, either demolished or replaced. One such home is Robert Evans's first log cabin, which was supplanted by a Victorian house owned by Edgar Franklin. Later, Franklin's house became Ruth Sprecher's home and beauty shop. Today, her shop and the small barbershop next door have been replaced by the Monroe Federal Savings and Loan building.

Hartman and Grace Kinney left no descendants, but their memories will always be alive in the Kinney files kept at the Tippecanoe Historical Museum in the Grace Kinney room. In that same way, many other family histories will be preserved because they have been donated to the museum.

However, other longtime family ties can still be found today. Robert Evans, who first owned the land where Tipp City sits, had 16 children. The family names of his descendants have changed and expanded over the last 180 years with each generation. Evans, Barnhart, Eickhoff, Johnson, Eidemiller, and Heffner are only a few of the families that can trace their ancestors to before Tippecanoe was founded.

This last chapter is dedicated to one of the direct lines of descendants from Robert Evans and his second wife, Mary. It is hoped that this book will encourage more families, whether they are descended from early Tippecanoe families or not, to preserve their heritage by labeling photographs and compiling their own family histories. Everyone's story has importance, and only by weaving them together can we truly understand how the past reveals the foundation of the future. Every family has stories to tell of the people who were so busy living their lives that they did not know they were living history.

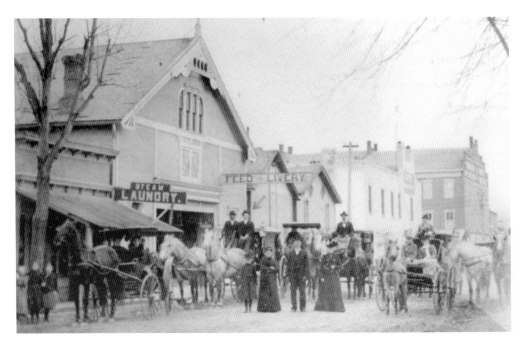

Known Only in the Past
In the early days of photography, people were fascinated by the thought of preserving their images, and they flocked to have their photographs taken. The names of those in the above photograph from the late 1800s are unknown, but when they gathered on Second Street just north of Main Street, they were friends or relatives and known to each other. Unfortunately, their contributions to Tippecanoe's story can only be imagined.

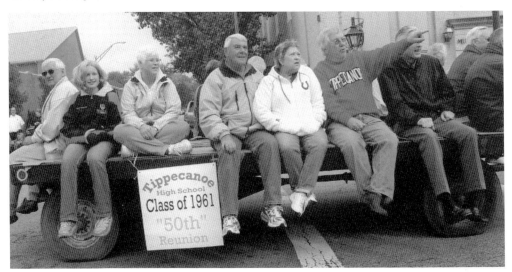

Remembering Their Stories
This photograph of the 50-year reunion of the Tippecanoe High School class of 1961 was taken during the Mum Festival Parade. These residents spent their school years together, and 50 years later they came back to tell their stories again. Their contributions to Tipp City's story need to be preserved and remembered for those who come after. (Courtesy of Carla Ungerecht, editor of *Tippecanoe Gazette*.)

CHAPTER SEVEN: THE ROBERT EVANS LEGACY

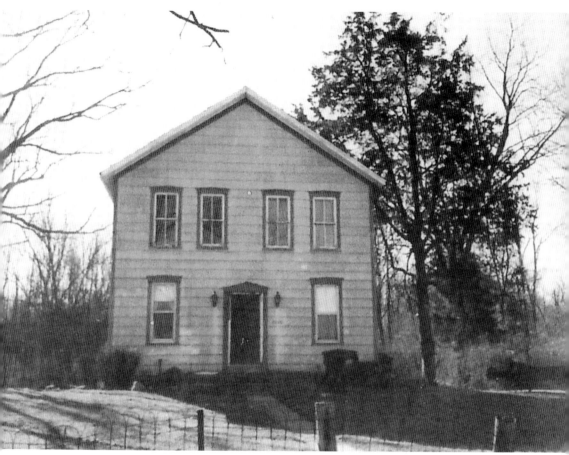

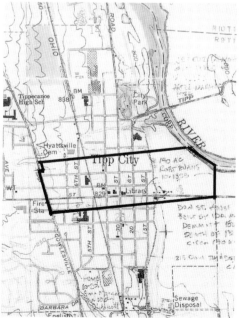

Robert Evans's Lineage
Robert Evans was born in 1789 in Georgia. When he was 15, his father, Joseph, and family settled in Ohio on land straddling the Miami and Montgomery County lines. After building the original log cabin, Joseph built what he called his "modern" house (above). Robert inherited that property and later sold it to buy 140 acres where Tipp City now sits (left). He then sold that land to his brother-in-law John Clark, who established Tippecanoe. Evans lived contentedly on his new farm, on the north side of Evanston Road halfway between County Road 25A and Peters Road, until his death. His house is still standing and occupied. Many of his 16 children have left family legacies in the area, but only one direct line from Robert to the present day will be represented in this chapter. (Both, courtesy of Betty Eickhoff.)

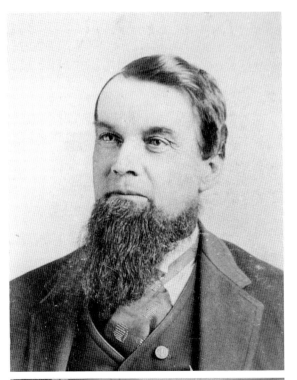

Squire Evans
Robert Milton Evans was born in 1845 to Robert and Mary Evans. He was called "Squire" after being elected justice of the peace, a position he held for 42 years. He inherited his father's property, and he later built a house on the southwest corner of 25A and Evanston, which is still standing. In addition to farming, he owned a store on the corner of 25A and Gingham-Frederick Road called Besom & Evans. He also worked to obtain the right-of-way for the Dayton & Troy Traction Line down County Road 25A. Squire Evans was one of the first persons in Tippecanoe to own a car and have a telephone. Evanston Road was named in his honor.

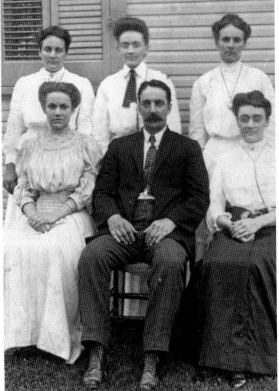

The Descendants Continue
This photograph shows Squire Evans's children. From left to right are (first row) Rhoda, Korah, and Lillie; (second row) Sarah Arletta "Lettie," Anna Predempsy "Dempsy," and Laura. (Both, courtesy of Betty Eickhoff.)

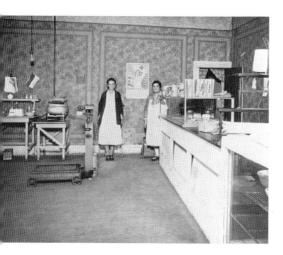
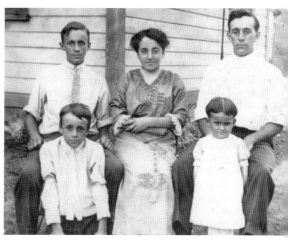

Independent Woman

In 1891, at age 19, Lettie Evans married Harry Barnhart against the wishes of her father, Robert "Squire" Evans. He wrote in his journal, "Arlettie left home by her own choice and contrary to the advice and wishes of her parents, choosing to disobey their request, which request was reasonable." Her father even put in his will that she could not inherit her share of his estate as long as she was married to Barnhart. As Evans predicted, Harry "took to the saloons and caused a turbulent marriage" for his daughter. In the right photograph are the five children of Arletta "Lettie" Evans and Harry Barnhart. They are, from left to right, (first row) Herschel "Slim" and Lois; (second row) Milton "Mit," Monna "Polly," and Clarence "Jim." In the days before welfare and government aid, Lettie had to work hard to keep the family together. Every week, she baked cakes, pies, and other treats and took them by wagon to sell at an open market in Dayton, but her marriage continued to crumble. Divorce was scandalous in the early 1900s, and two attempts to separate were withdrawn. In 1919, the marriage was dissolved. Her father did not live to see Harry Barnhart out of her life, but with her inheritance of $5,883.91, Lettie bought a house on Fourth Street so that she and her children would never be homeless. She went into business, opening a cream station to separate cream from milk with her friend, Hettie Hartley. In the left photograph, Lettie (left) and Hettie pose in the station. Lettie later ran bakeries at two different places on Main Street and was known for "the best soft sugar cookies in the world!" In her later years, she supported herself as a live-in housekeeper with several families. While working for Coonie Bowmaster, a retired barber with a wooden leg, she became ill and died in 1950 at age 78. Lettie Barnhart was a deeply religious woman. A Bible carried by her father, Squire Evans, during the Civil War was passed down to her. She gave it to her son, Clarence, to carry while fighting in World War I, and then to her grandson Donald during World War II. That small Bible saw all three men return home safely. Part of the touching note she wrote to her grandson said, "Be a good boy, Donnie, is the wish of an old grandmother. Be good." (Both, courtesy of Betty Eickhoff.)

Deadly Crash

Milton "Mit" Barnhart was born to Lettie and Harry Barnhart in 1898. Barnhart, a handsome and outgoing man, married Cordella "Curley" Hoover in 1919, and they had four children, Betty, Don, Jean, and Peggy. Mit and Curley are seen in this photograph. Every evening when he arrived home from working at the Dayton and Troy Electric Traction Line, Mit Barnhart could barely get in the front door with a child on each leg and two more on his arms. In 1932, the traction line closed, and Barnhart was out of a job. He took classes at Miami Jacobs Business College, and his next job was with National Transit Freight Company in Dayton. This proved to be a fateful decision. In September 1934, he was asked by his boss to go to an area trucking meeting in his stead. For this special occasion, Barnhart bought his first suit for $21 and wore it to the meeting in Cincinnati. The next morning, on the way home, at a deceptively dangerous curve with no guardrails or signs, he lost control of the car and ploughed into a pole. Barnhart was pinned under the steering wheel when the car burst into flames, killing him and the three passengers. That September morning was Mit and Curley's 15th wedding anniversary. (Courtesy of Betty Eickhoff.)

Barnhart Children View the Crash
A black wreath was nailed to the door of the Barnhart house on Main Street, where the new fire station now stands. Mit Barnhart's casket was set in the corner of the front room. The outpouring of sympathy was overwhelming. His daughter, Betty, remembers sitting on the front step as a Cincinnati & Lake Erie bus stopped in front of their house several times a day, beeped its horn, and dropped off floral arrangements. The flowers were so numerous that they had to be banked on all four walls from floor to ceiling, and a truck was hired to carry them to the church and then to Maple Hill Cemetery. The funeral service was held at the Methodist Church on Third and Main Streets. The crowd of mourners overflowed the sanctuary and balcony and extended into the hallway. Mit Barnhart was buried in the second new suit bought for him that week. (Courtesy of Betty Eickhoff.)

Letter from Daddy
The summer that Betty Barnhart was 10, she stayed with relatives in Cleveland. Her daddy wrote this letter to her on a Dayton & Western Traction Line ticket. The Dayton & Western was a branch of the Dayton & Troy Electric Traction Line that went from Dayton to Cleveland. (Courtesy of Betty Eickhoff.)

Gathering Family History

Betty Barnhart, Milton and Cordella's oldest daughter, married Bill Eickhoff in 1939. The couple is pictured above on their wedding day. Together, the two of them made an extensive collection of documents, photographs, and anecdotal stories about their family histories. Betty said, "We [our families] went back to the beginning of Tipp City," and her interest in knowing as much as she could about them grew from there. She gathered the information, and Bill put it on the computer and printed hard copies until his death in 2007. Now, their children, Jill, Lynn, and Mark, and their grandchildren, share Betty's interest in family history and add their own research to her numerous boxes and notebooks. One of her treasured mementos is Robert Evans's original journal, where he kept records of all his business transactions in his own handwriting (below). Betty is now one of the older members of the Tipp City community; many conversations that this author has had with people about Tipp City ended with, "Go ask Betty Eickhoff. She can tell you." She delights in telling what she remembers, correcting a lot of misinformation that has been passed down over the years. Sometimes she will even share some of the scandalous gossip from yesteryear. She remains in contact with many descendants of families on the different branches of the Evans family tree. Together, they plan reunions, share information, and strengthen family ties to be passed down to future generations. (Above, courtesy of Betty Eickhoff; below, photograph by author.)

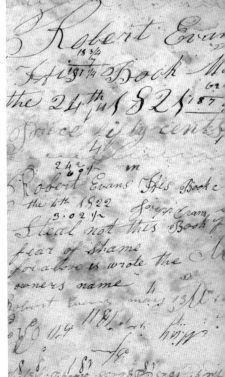

So Many Have Come After

Robert Evans could not have envisioned the Tipp City of today or the hundreds of families that now populate his former property. Without his vision to build a life for himself and his family in the Ohio wilderness, this photograph of a summer reunion of the Eickhoff family would not be possible. These family members represent only one of the lines of direct descendants who are living reminders of the town on the canal. (Courtesy of Betty Eickhoff.)

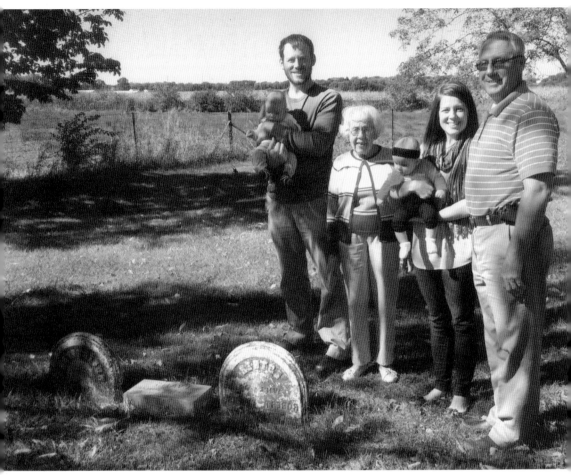

Evans's Legacy
Each member of this family carries a tiny bit of Robert Evans's DNA. Shown here are, from left to right, Scott Eickhoff (holding Liam Eickhoff), Betty Eickhoff, Jessica Eickhoff Persinger (holding Kendall Persinger), and Mark Eickhoff. They are standing beside the graves of Robert Evans and his first wife, Esther. Betty is a great-great-granddaughter of Evans and his second wife, Mary. Betty's son Mark is a great-great-great-grandson of Evans. His children, Jessica and Scott, are four "greats," and their children, Kendall and Liam, are five "greats." Each generation is the beginning of the next. Remember them all. (Photograph by author.)

ABOUT THE TIPPECANOE HISTORICAL SOCIETY

The Tippecanoe Historical Society has been invaluable in researching this book, along with everyone who shared their family stories. Thanks to the hard work of many at the museum, photographs and information about Tippecanoe are readily available. Do not miss the annual Cemetery Walk in June or the Tour of Homes in December when more Legendary Locals from history will tell their stories.

INDEX

Ahmed, Gail, 8, 86
Ball, Leonard, 8, 43, 46, 49, 54
Barnhart, Arletta "Lettie," 118, 119
Barnhart, Cordella "Curley" Hoover, 120
Barnhart, Milton "Mit," 119, 120, 121
Bartmess, James, 43, 44
Bauder, Wendy, 83
Bayliff, Jim, 8, 42
Bayliff, Leigh Ann, 42
Berning, Julie Drake, 47
Bohlendar, Peter, 7, 35, 94
Booher, Levi, 7, 13, 14
Booher, Nettie, 32
Bowling, Vernon "Jack," 32, 34
Bowman, Joseph, 63
Bowman, Joseph Warren, 63
Brown, Ethan Allen, 7
Brump, Bella, 43, 44
Burbagher, Charlie, 59
Burwell, Ralph, 97
Butler, Basil, 55
Butler, Mary Prill, 8, 55
Chaffee, Sidney, 7, 9, 18, 67
Cheadle, Jack, 81
Clark, John, 4, 7, 9, 10, 12, 13, 117
Clark, Mordecai, 18
Clawson, Carl "Jointer," 8, 27
Clingan, Greta, 83
Cobb, Victor, 77
Cook, Dave, 8, 90
Cook, Sue, 8, 90
Coppock, Nevin, 8, 43, 50
Cost, Bill, 83
Cottingham, Lulu, 67, 75
Crane, Anna, 62
Crane, Edward, 62
Crane, Martha "Mattie," 102
Crane, William Woodward, 62
Crook, Savilla, 31
Crook, Thomas "Tommy," 31, 95
Davidson, Thomas, 74
DeLangton, Ethel Hartman, 104, 105

Detrick, Jacob, 7, 9, 23
Dixon-Engel, Tara, 32, 88, 89
Dorsey, Bill, 39
Eickhoff, Betty Barnhart, 10, 120, 121, 122
Eickhoff, Bill, 122
Evans, Jack and Stan, 16, 112
Evans, Joseph, 117
Evans, Robert, 7, 9, 10, 11, 115, 117
Evans, Robert "Squire," 118, 119
Fair, Floyd "Sonnie," 79
Favorite, Abraham, 16
Favorite, George, 16
Favorite, Harry, 16, 104, 106
Favorite, Jonathan, 16
Favorite, Mary Hartman, 16, 104, 105
Favorite, Uriah, 16
Feghtly, Sarah, 69
Fennell, Marilyn, 83
Finch, Clayton "Penny," 32, 33
Finch, Helen, 32, 33
Fleischer, Eva Wolfe, 36
Frings, Isabel, 4, 26
Frings, Otto, 4, 26
Frisz, Ray, 38
Fry, Mary Belle, 46
Garver, Abraham, 7, 22
Garver, Karl, 22
Hadden, Peg, 8, 82
Hampton, Lowell, 70
Harrison, William Henry, 13
Hartland, Rev. James, 92
Hartley, Nellie Freet, 98
Hartman, Dr. Abraham, 103
Hartman, Dr. Samuel "Duff," 103, 104, 105
Harvey, Nonda Evans, 83
Hausfeld, Rhoda, 34
Heater, Terry, 84
Henn, John, 14
Hill, Eva, 100
Hill, Frank "Speed," 100
Hoagland, Kiel, 9, 11
Holtvoight, Henry, 36

Holtvoight, John, 30, 36, 65
Honeyman, Gordon, 24, 85
Hoover, Leota, 57
Horton, Harry, 32
Horton, Joshua, 32
Horton, Ramon, 32
Howell, Adrienne, 56
Howell, Dr. Albert, 8, 56
Hyatt, Henry, 9, 11, 14, 16, 61
Hyatt, Mary, 14, 16
Jackson, Mike, 32, 88, 89
Jackson, Ray, 76
Jackson, Robert, 78
Jay, Thomas, 7, 67
Johns, James, 7, 12
Johns, Uriah, 7, 12
Johnsen, Kate Kyle, 94
Johnson, Grant "Handsome," 77
Keppel, Anne, 8, 43, 52, 53
Kerr, Ellis Hamilton, 66
Kerr, Furnas, 66
Kerr, George, 66
Kerr, Hamilton II, 66
Kerr, James, 66
Kerr, James T., 66
Kerr, Raymond, 66
Kessler, Catherine, 67, 75
Kessler, William, 74, 109
King, Stewart, 8, 43, 55
Kinney, Grace, 4, 16, 68, 95, 105, 115
Kinney, Hartman, 4, 16, 68, 95, 104, 105, 106, 115
Kiser, Foster, 65
Kiser, Isaac, 61, 65
Kiser, Maynard, 30, 36, 65, 112
Krise, Henry, 9
Kuziensky, Karen, 68
Kyle, Harry, 94
Kyle, James, 8, 49, 94
Kyle, Thomas Jr., 8, 94
Kyle, Thomas Sr., 51
Langley, Elmer, 32
Langley, Helen, 32, 33
Leiss, Wilmer, 25, 109
Linn, Charles, 27

INDEX

Maddux, Alice Puterbaugh, 107
Maddux, Bernice, 37
Mann, Carrie Hartman Kinney, 104, 105, 106
Mann, Clifford, 104
Martin, Ron, 48
Mast, Danza "Betty," 95, 111
Mast, Erma "Jim," 95, 111
Michael, Mary Kyle, 8, 51, 94
Miles, Ahijah, 63
Miller, Jerry, 4, 68
Miller, Liz, 4, 68
Moore, Ethel, 40
Moore, Sam, 40
Morlidge, Dr. E, 70
Nunlist, John, 9, 19
Nunlist, Julia Messer, 19
Parsons, Alva, 112, 113
Parsons, Jeanne, 112, 113
Pittenger, Gordon, 93
Pittenger, Joanna, 93
Puterbaugh, Dr. E.G., 107
Re, Ron, 4, 8, 80, 81
Richards, Allen "Alkie," 8, 60
Rogers, Claudia Huntsberger, 53
Rogers, Tom, 57, 58
Rohrer, Jacob, 7, 9, 15, 61
Rouzer, Daniel, 101
Seagraves, Chris, 87
Scheip, James Augustus, 7, 17, 20
Scheip, James Russell, 20, 21
Scholl, Cora, 37
Seybold, Rita, 48
Shaffer, Anna, 75
Smith, Dale, 38
Smith, Evalyn, 41
Smith, George, 9
Smith, John "Blackie," 24, 96
Smith, Nellie Herr, 24, 32, 67, 95, 96
Smith, Ross, 41
Spitler, Susie, 68
Sprecher, Ned, 4, 95, 108, 109
Sprecher, Ruth, 25, 115
Staup, Bettie Jackson, 48
Thompson, Sallie, 61, 66
Thuma, Ron, 83
Timmer, A.W. "Pete," 29, 30
Timmer, Claire, 8, 30
Timmer, Gerhart, 7, 28, 30
Timmer, Lota Hartley, 29, 30
Timmer, Matt, 8, 30
Timmer, Rose, 30
Timmer, Thomas Gerhart, 30, 36, 65
Timmer, Wilhelmina, 28
Tipp City Volunteer Fire Department and Emergency Squad, 70, 72, 73
Tippecanoe cross-country team, 58
Tippecanoe football team, 59
Tippecanoe girls basketball team, 57
Tippecanoe historical play, casts, 114
Tippecanoe volleyball team, 57
Trost, Franklin Kenneth "Ken," 95, 110
Trupp, Charles, 7, 67, 71
Volke, Rol, 110
Wahl, Annie, 91
Wahl, Bob, 91
Wahl, Jackie, 4, 8, 91
Wahl, Katie, 4, 91
Wenzlau, Charles "Weez," 99
Wharton, Sam, 4, 58
White, Fred, 45, 47
White, Ruth Ann Jackson, 47
White, Ruth Sims, 46, 47
Wiggs, Katy Badgley, 47
Wilson, Howard "Jim," 4, 84
Wilson, Mary Lou, 4, 84

AN IMPRINT OF ARCADIA PUBLISHING

Find more books like this at
www.legendarylocals.com

Discover more local and regional history books at
www.arcadiapublishing.com

Consistent with our mission to preserve history on a local level, this book was printed in South Carolina on American-made paper and manufactured entirely in the United States. Products carrying the accredited Forest Stewardship Council (FSC) label are printed on 100 percent FSC-certified paper.